AROUND
STAFFORD

From Old Photographs

AROUND STAFFORD

From Old Photographs

JOAN ANSLOW & THEA RANDALL

AMBERLEY

First published by Alan Sutton Publishing Limited, 1991
This edition published 2010

Amberley Publishing
Cirencester Road, Chalford,
Stroud, Gloucestershire, GL6 8PE

www.amberley-books.com

British Library Cataloguing in Publication Data.
A catalogue record for this book is available from the British Library.

ISBN 978 1 84868 501 7

Typesetting and origination by Amberley Publishing
Printed in Great Britain

CONTENTS

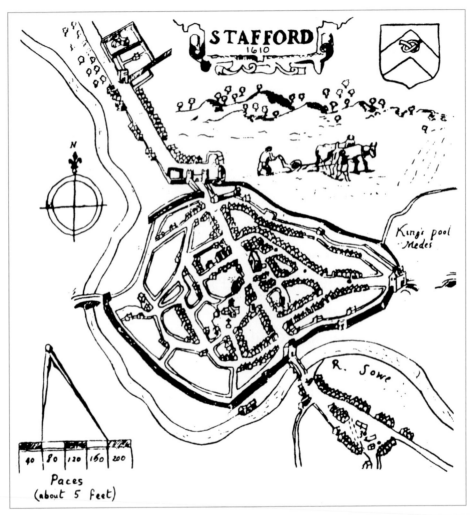

THIS SEVENTENTH CENTURY MAP OF STAFFORD shows the old walled town. This ancient layout can still be traced today from Street names such as Back Walls South, North Walls, Greengate Street, Eastgate Street and Gaolgate Street.

INTRODUCTION

Stafford, the county town, is situated in the centre of Staffordshire, bounded to the south by the open spaces of Cannock Chase, once a medieval hunting ground, and to the north, the east and the west by agricultural land, dotted with small villages. Stafford was founded in 913 when Ethelfleda, widow of the Earl of Mercia, fortified an area of high ground against the Danes. It was protected by the River Sow, an extensive area of high marshland and, in the Middle ages, by walls and gates. The layout of the streets, as can be seen from the map of 1610, can still be identified in the town centre, the street names reflecting the medieval walled town, Greengate Street and Gaolgate Street still form the north-south axis of the town while North and South Walls follow the lines of the original town walls, demolished during the Civil War.

In common with many county towns, certain functions and services have been centred on Stafford over the centuries. It has always been a market town serving its agricultural hinterland, receiving its market charter in 1251, though today's new indoor market hall is a far cry from the cattle market of the nineteenth and early twentieth centuries. Elizabeth I decreed that Assize Courts should be held in Stafford 'ever after' and a large hall, built for this purpose, can still be seen in the Market Square. The current Shire Hall, built in 1798, dominates all photographs of the Square though, with the opening of the new Crown Court in Victoria Square in 1991, it is no longer the seat of justice. The county's administration has been based in the town since the sixteenth century, first with the Court of Quarter Sessions and, since 1889, Staffordshire County Council. County Buildings, completed in 1895, remains one of the finest examples of late Victorian municipal architecture in the county.

During the eighteenth and nineteenth centuries, Stafford's principal industry was the manufacture of boots and shoes, resulting in a famous toast by the playwright, R. B. Sheridan, the town's M.P: 'May the trade of Stafford be trod underfoot by all the world.' In the later nineteenth century the rise of shoe factories, concentrated in the north part of the town, prompted the development of many new streets to accomodate workers in the industry. The railway came to Stafford in 1837, the Castletown area being developed in the later nineteenth century to house railway workers. In the surrounding villages agriculture was the main occupation along with its related crafts. The large and small country houses and their estates also provided work for local people in these rural communities, as did the railway in those villages through which it passed.

During the twentieth century, boots and shoes gave way to engineering as the dominant industry in the town. New housing joined the town physically to many former villages and hamlets, such as Baswich, Walton, Castlechurch, and Doxey. Likewise, most of the villages which appear in this book now have modern housing developments, none more so than Gnosall. However, Stafford's immediate countryside retains its rural attraction, peace and tranquillity.

The town was described in 1819 as the 'dullest and vilest town in England'. Some years later, Charles Dickens was equally uncomplimentary about it – 'as dull and dead a town as anyone could desire not to see'. Yet, as may be seen in many of the photographs in this book, the town possessed a handsome main street and Market Square, with fine examples of architecture from the sixteenth, seventeenth and eighteenth centuries. In addition, a considerable number of timber-framed and thatched cottages were to be found in smaller streets.

A great deal of this architectural heritage survived until the early 1950s. Since then, rapid advances and sweeping changes in response to the pressures of a growing population, increasing traffic levels and consumer demand have resulted in the loss of many landmarks much loved by Staffordians. In recent years, however, there has been a growing appreciation of the town's heritage which has resulted in positive and welcome steps to preserve its surviving architectural legacy.

This collection of photographs covers the period from the 1850s to the 1950s. Many of the photographs are unusual and have not been published previously. They have been chosen to show how familiar scenes have changed and how people lived, worked and enjoyed simple pleasures. Inevitably the town of Stafford has the lion's share. We have not attempted to present a comprehensive coverage of the area but rather to give a flavour of the past and a glimpse of a way of life that has gone forever. It is important, however, to remember that old photographs often give a rose-tinted and nostalgic image of days gone by. The realities of poverty, sickness and unemployment did not make attractive pictures to be captured on camera. While we can appreciate the good things which we have lost, we should also remember the hardships that went with them.

CHAPTER ONE

THE STAGE IS SET

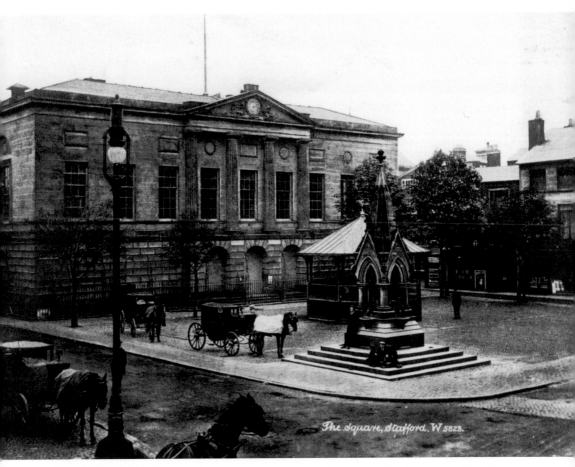

STAFFORD'S MARKET SQUARE (*c.* 1905) has always been the hub of the town. The Shire Hall was built in 1798 and was used as a courthouse until 1991 when it was replaced by a new building in Victoria Square. The bandstand was removed to Victoria Park, and the Jubilee Fountain of 1887 was smashed and used as hardcore in 1934.

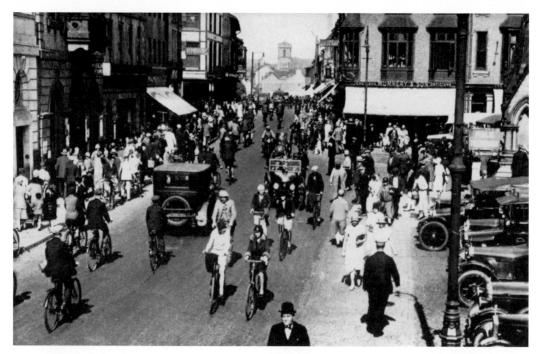

THE MARKET SQUARE IN THE 1920s. The Police Station can be seen on the left of this view.
In the early 1930s it was removed to Bath Street. The bicycle was a very popular method of
getting about, particularly when workers were going to and coming from local factories in the
rush hour. The streets were so congested that if one cyclist fell off, they all fell off.

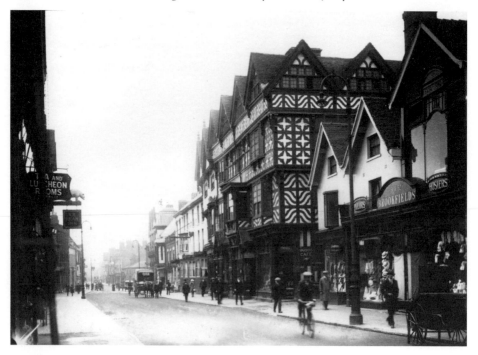

GREENGATE STREET in 1912.

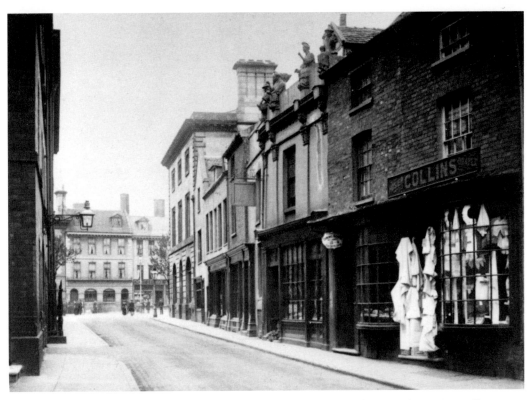

MARKET STREET in the 1920s. The figures over the shop centre right were of eastern tea sellers; the building used to be a tea warehouse.

MARTIN STREET *c.* 1900. The new County Council buildings can just be seen on the left. Now the whole street is taken up with County Council departments.

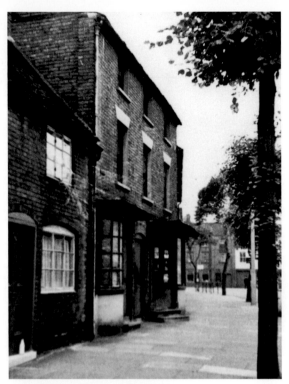

EASTGATE STREET in the 1920s. One of the oldest streets in the town, it led to the East Gate and on to the Uttoxeter Road. Izaak Walton, who wrote *The Compleat Angler*, was probably born in this street.

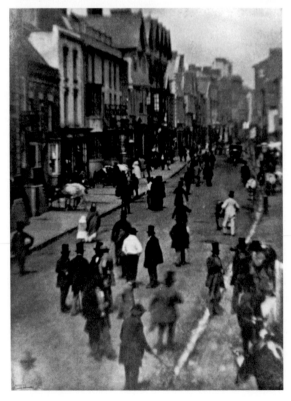

GREENGATE STREET in this early photograph taken in 1858. Note the cows on the left.

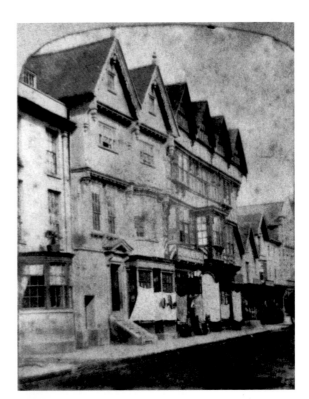

THE ANCIENT HIGH HOUSE
is one of the finest remaining
timbered town houses left in
England. This view is from 1880.

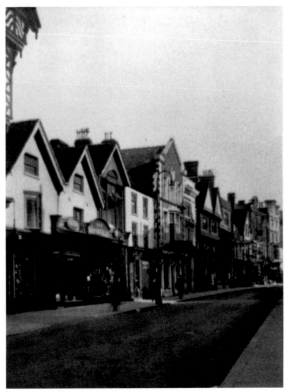

GREENGATE STREET, *c.* 1906.
This part of the street was rarely
photographed.

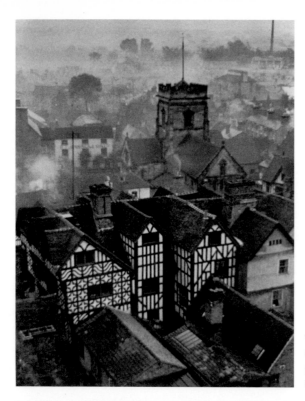

VIEW FROM ST. MARY'S
CHURCH TOWER of the rear of
the High House and St. Chad's
Church.

TUDOR HOUSE was built on
the south bank of the River Sow
on the site once occupied by a
medieval hospital.

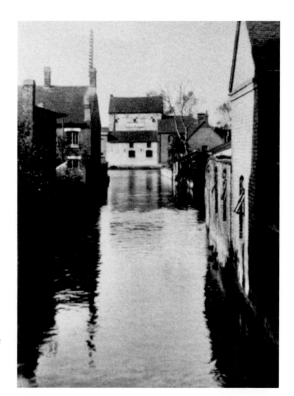

THE RIVER SOW ran on three sides of the
original town, but now winds through the
south of the town. It is seen here from the
Green Bridge which led to the South Gate.

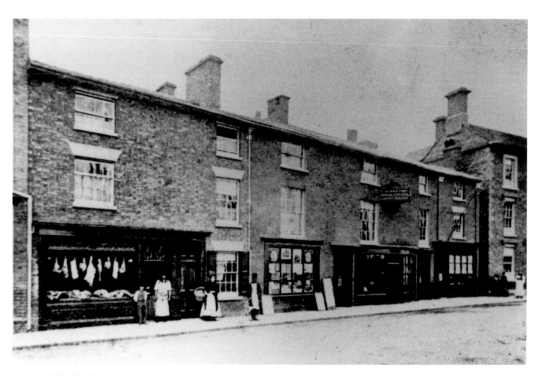

BRIDGE STREET, *c.* 1910.

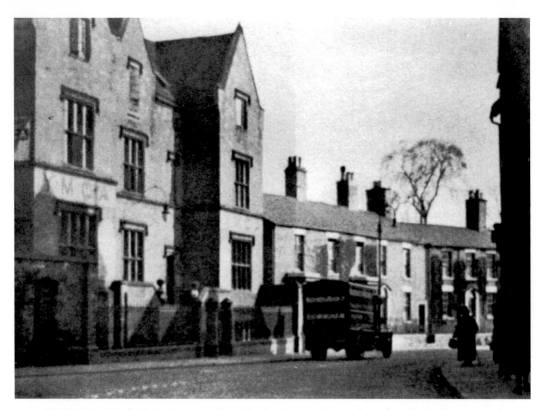

CAMDEN PLACE, Wolverhampton Road, in the 1930s. This was lost when Stafford's new road system was set up in the late 1970s.

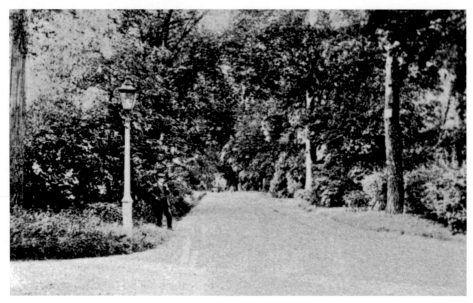

THE ENTRANCE TO ROWLEY PARK. Rowley Park was an estate of superior villas built on part of the grounds of Rowley Hall by the Stafford Land Building and Improvement Co. Ltd in 1866.

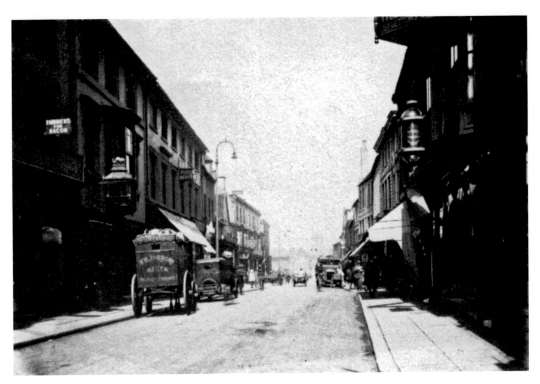

GAOLGATE STREET, *c.* 1910.

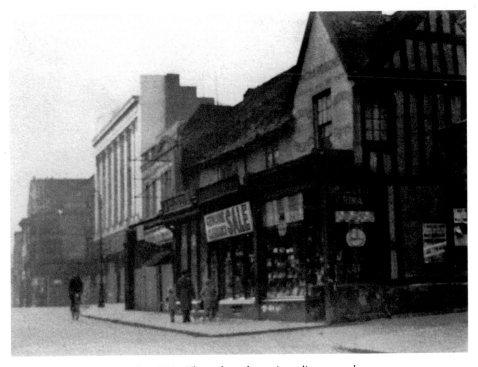

GAOLGATE STREET in the 1930s. These shops have since disappeared.

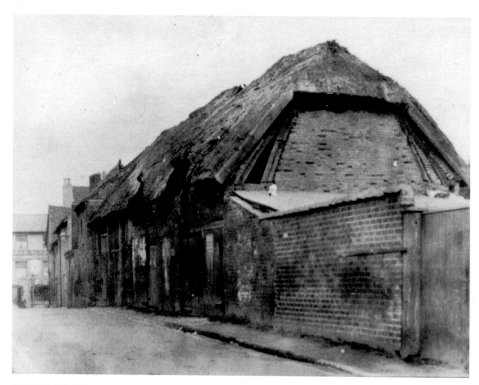

STAFFORD STREET in 1911 showing the thatched cottages which were once commonplace in Stafford, and which were probably here when King James I visited Stafford in 1617.

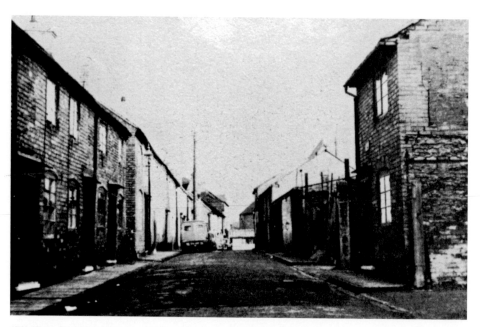

STAFFORD STREET in the 1930s. These cottages have now been entirely replaced with shops.

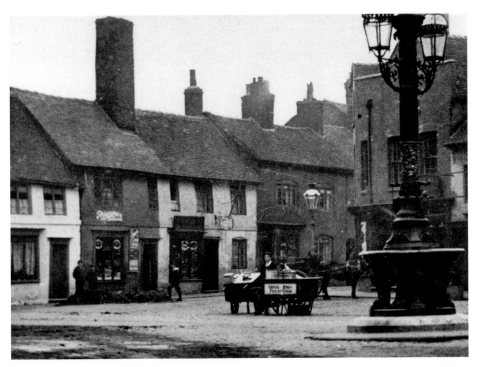

GAOL SQUARE before 1910. The drinking fountain was erected in 1889 in memory of Thomas Sidney, a local boy who became Lord Mayor of London. It lasted until 1928 when a lorry backed into it and demolished it completely.

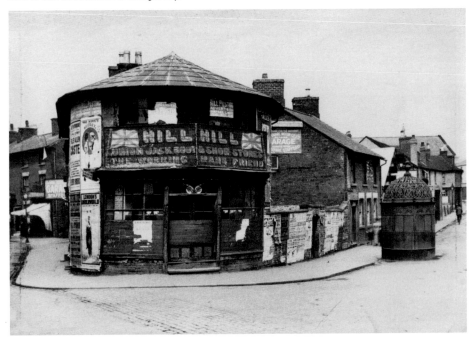

GAOL SQUARE in the early twentieth century. In 1904 John Hill was listed as being a shoemaker here.

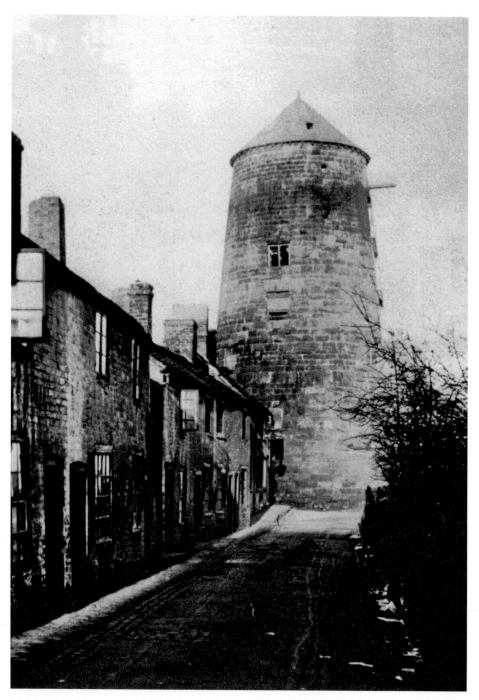

BROADEYE MILL was built in 1796 using stone from the Elizabethan Town Hall when it was replaced by the present Shire Hall.

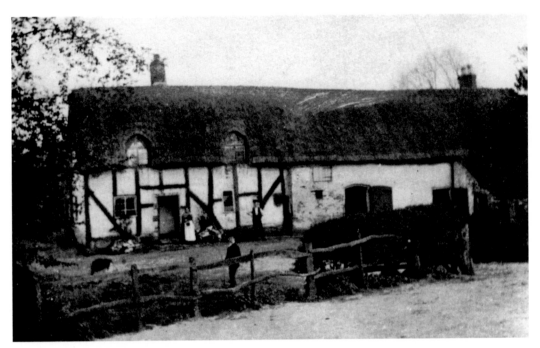

A THATCHED COTTAGE in Doxey, a delightful and unusual view, probably taken *c.* 1900.

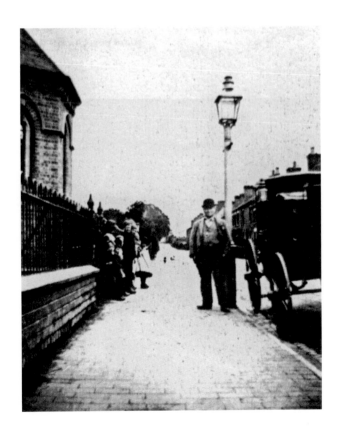

LITTLEWORTH SCHOOL was built in 1885 and also used as a church. William Marson is standing outside in Weston Road waiting to preach at a service in the brand new building.

RIVERWAY FARM was worked until the late 1930s when the land was sold to the County Council who built Riverway Secondary Modern Girls School on the site.

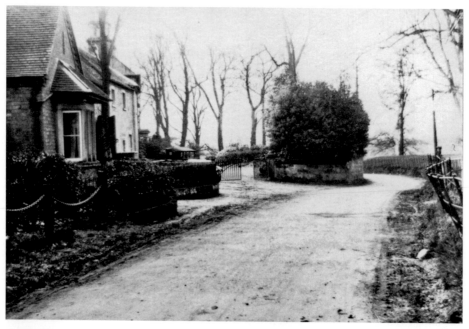

SILKMORE LANE in 1900 was a rural road through fields. Today it is in the middle of a built up area.

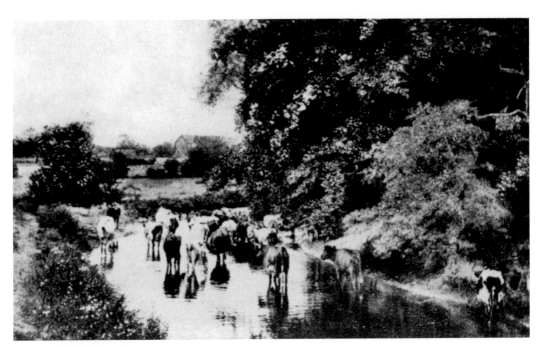

THE RIVER TRENT AT SHUGBOROUGH *c.* 1905.

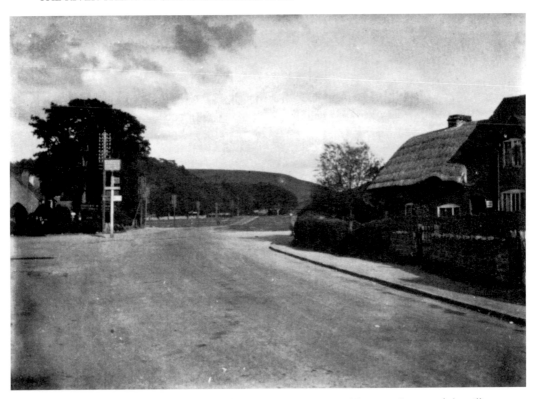

MILFORD *c.* 1900. Many a Sunday School outing was enjoyed here, and some of the village people offered light refreshments.

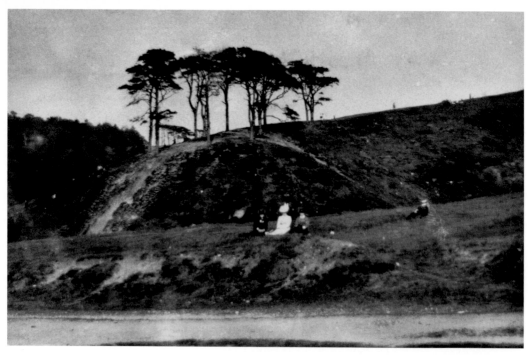

A FAMILY PICNIC AT MILFORD *c.* 1890.

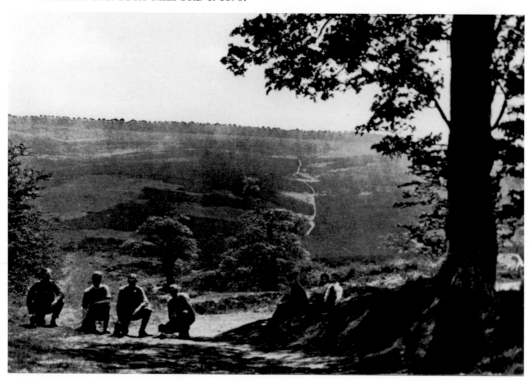

SOLDIERS FROM BROCTON CAMP enjoying a brief respite on Cannock Chase before going to France in the First World War.

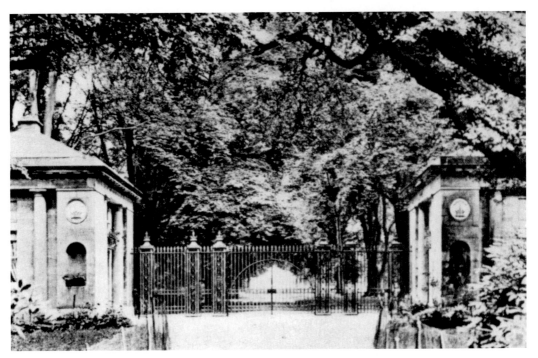

THE MAIN GATES OF SHUGBOROUGH HALL AT MILFORD, the seat of the Earl of Lichfield.

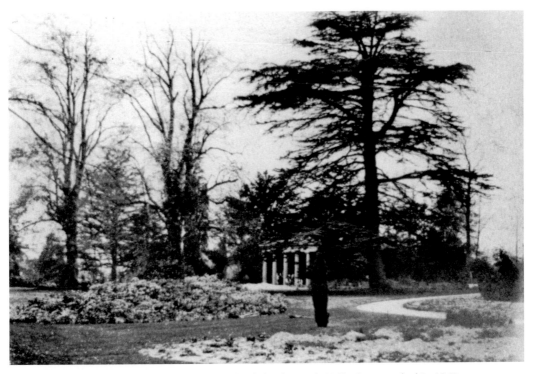

THE TEMPLE OF DIANA in the grounds of Shugborough Hall, photographed in 1863.

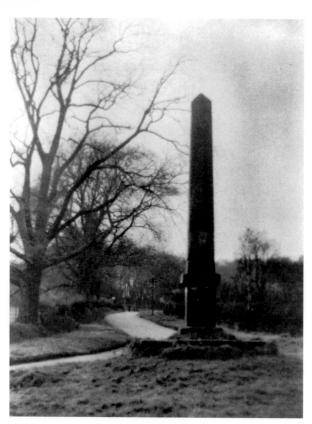

TIXALL MONUMENT is a hexagonal stone cross brought here from South Wales in 1803. It carries the date 1776 and now stands at a crossroads.

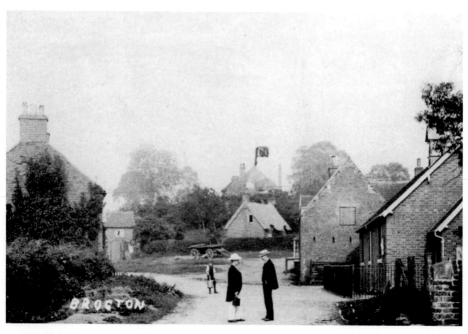

BROCTON VILLAGE, *c.* 1905.

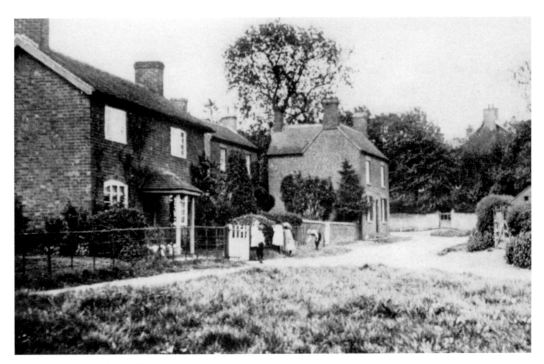

CHEBSEY VILLAGE, *c.* 1905.

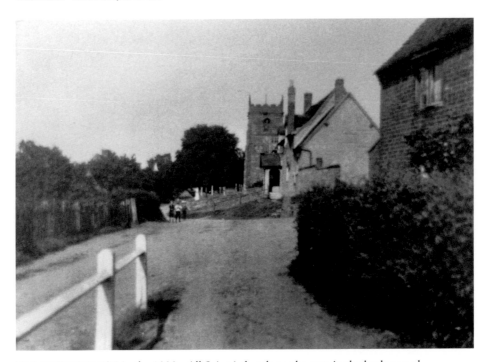

BRADLEY VILLAGE in the 1920s. All Saints' church can be seen in the background.

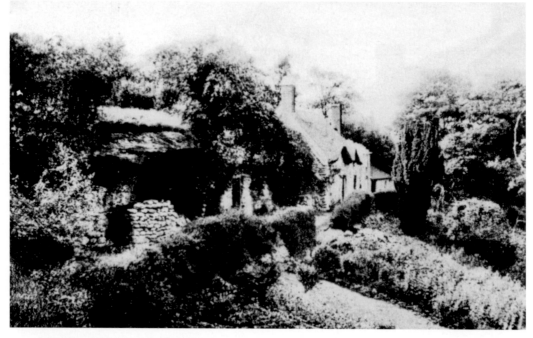

TINKERBOROUGH NEAR SALT was a stone quarry. Some of the cottages for the workers were built backed on to hewn rock caves.

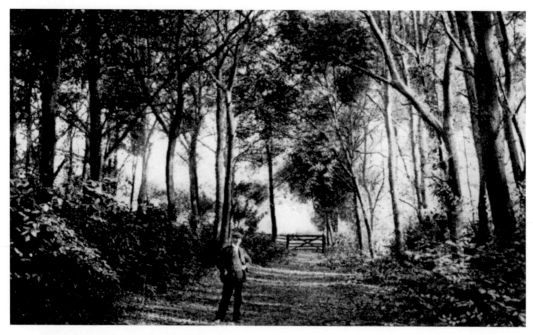

THE WOODS AT TINKERBOROUGH.

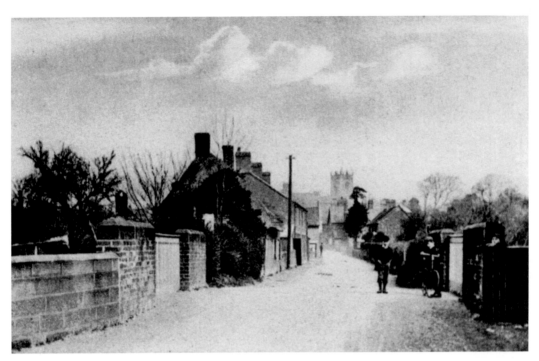

GNOSALL, *c.* 1905.

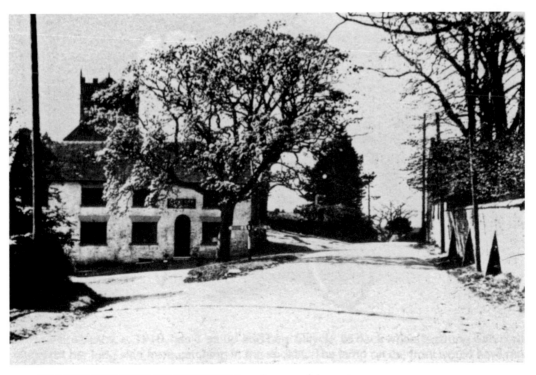

ST. MICHAEL'S CHURCH, ELLENHALL at the turn of the century.

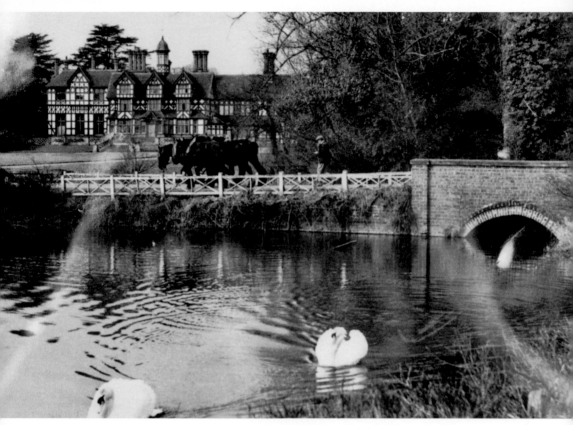

SEIGHFORD HALL in the 1930s, originally an Elizabethan house. It has had additions over the years, and is now a nursing home.

CHAPTER TWO

BICYCLES, BROUGHMANS AND BUSES

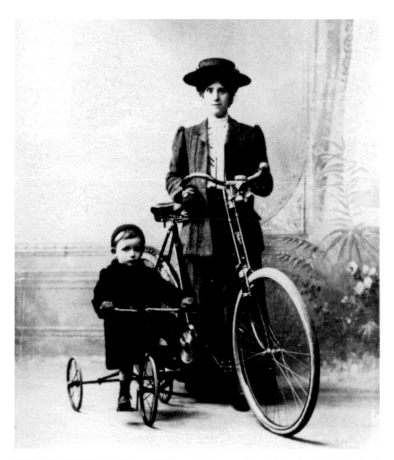

THE STAFFORD LADY, *c.* 1910 has a 'sit up and beg' bicycle. Its back wheel is strung with cord to prevent her long skirt from ctching in the spokes. The lamp on the front would have run on paraffin and cost about 6*s.* 6*d.* The small boy's tricycle would have cost about 20*s.* 9*d.*, beyond most working parents' pockets.

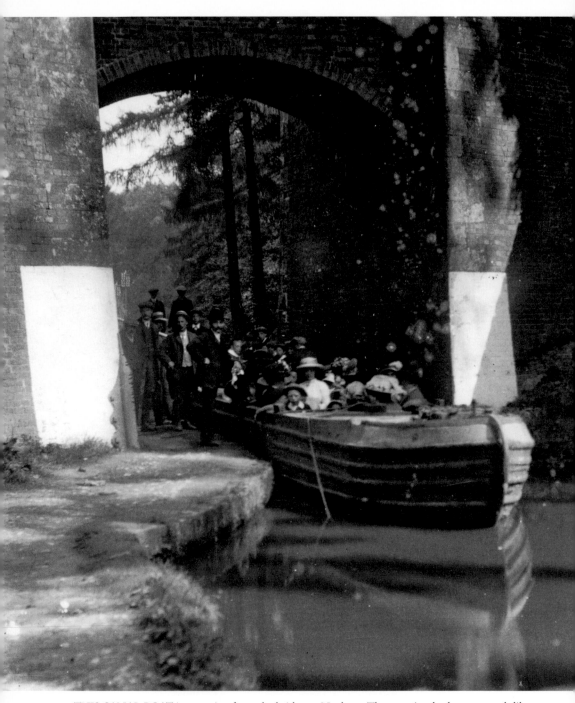

THIS CANAL BOAT is emerging from the bridge at Norbury. The occasion looks very much like one of the Sunday School 'treats' which were very popular *c.* 1905.

A SALT CART. Stafford had two salt works. Until about 1915 salt was sold in large blocks and hawked round the streets in carts like this one coming from the salt works in Common Road.

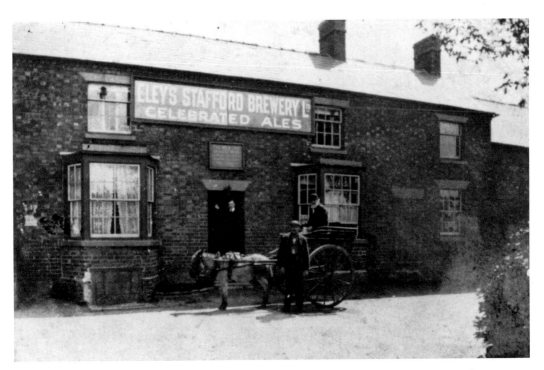

DONKEY CART outside the Railway Inn at Haughton *c.* 1910. The Inn is now a private house, the station closed and the line taken up.

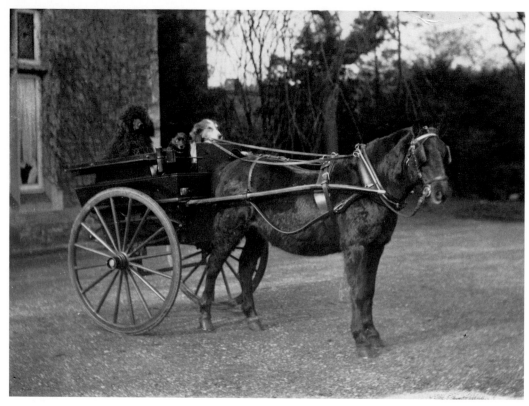

GOVERNESS CART, owned by a Stafford family who employed unusual coachmen!

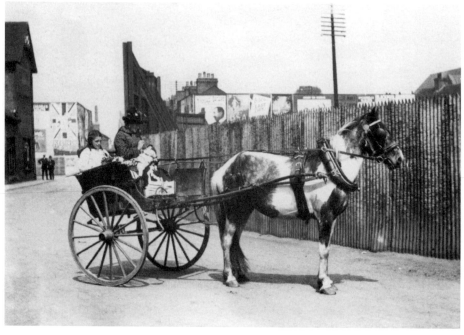

GIG IN TENTERBANKS, *c.* 1900.

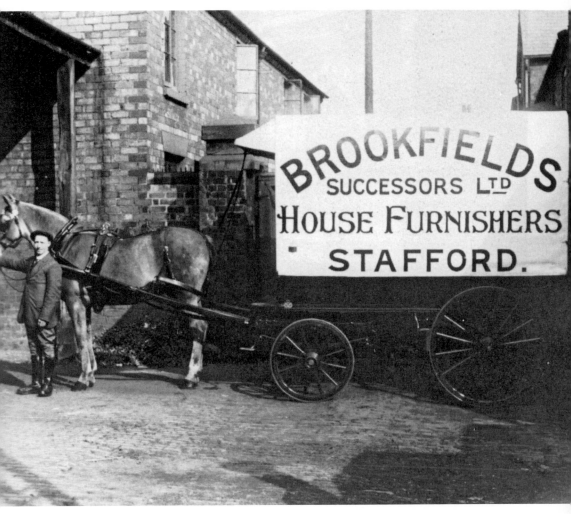

BROOKFIELDS had a comprehensive business empire in Stafford at the turn of the century. They not only owned a high-class department store but also operated as funeral directors, cabinet-makers, house agents, painters and decorators and removal contractors.

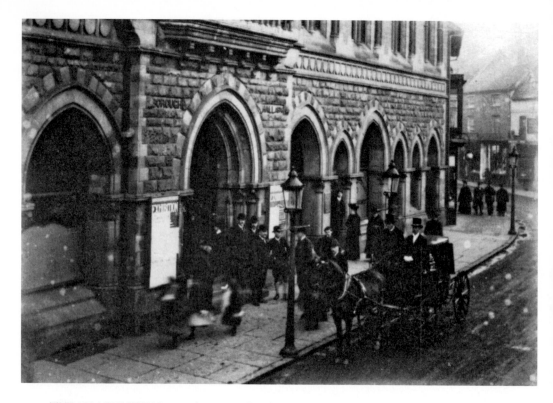

THE 1906 ELECTION not only saw a Liberal Government come into power, but also heralded the beginning of the end for horse-drawn vehicles, as shown by these two photographs outside the Bourough Hall on Polling Day.

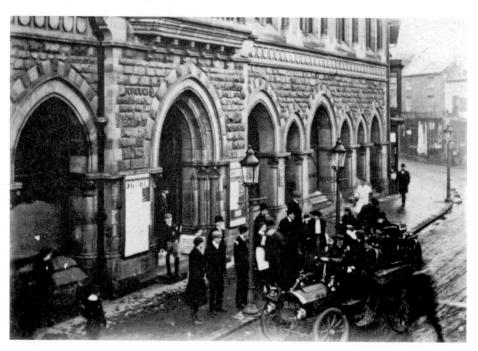

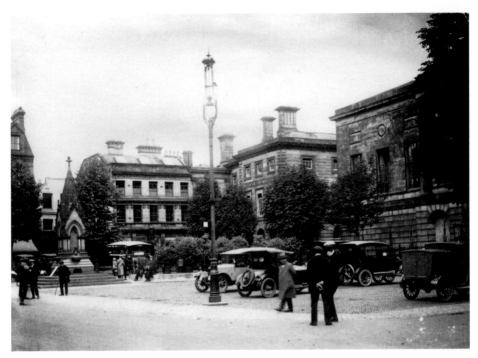

MARKET SQUARE, 1920. The hansom cabs standing in the Square had been supplanted by cars and buses. The fountain was erected to celebrate Queen Victoria's Jubilee in 1887 and broken up *c*. 1934.

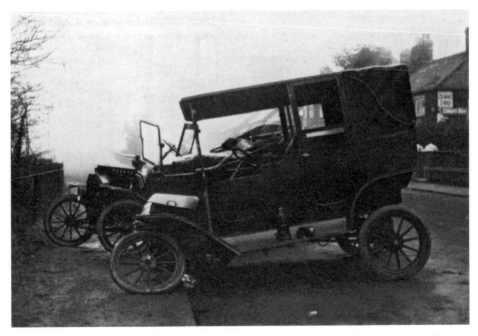

WITH THE ADVENT OF THE MOTOR CAR, unhappily came the first accidents. This one happened at the bottom of Queensville Bridge in the 1920s.

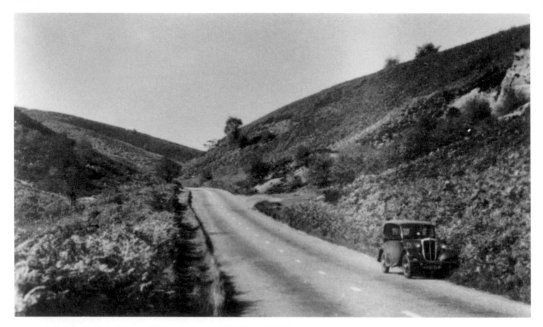

A LONELY CAR on the road through Milford Hills, *c.* 1935.

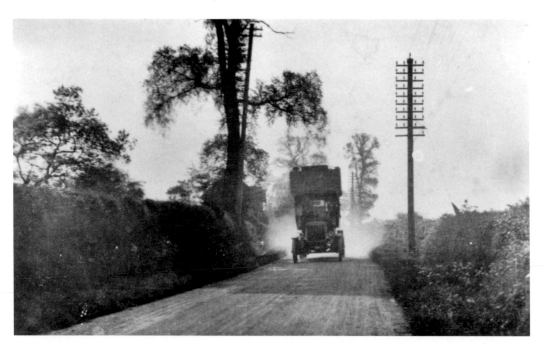

THE FIRST BUS FROM STAFFORD TO ECCLESHALL ran in the early 1920s and is seen here near Great Bridgeford.

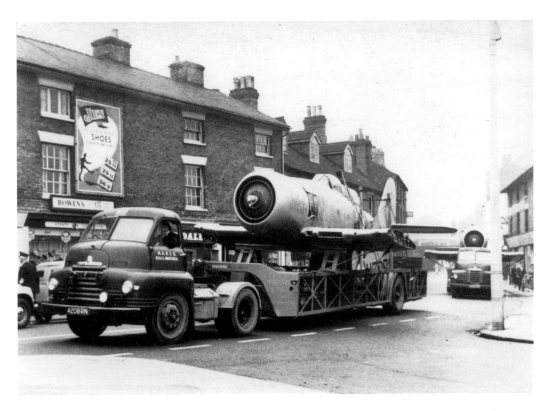

MILITARY EQUIPMENT being transported through Stafford was a familiar sight during the Second World War. The aeroplane is being carried through the Foregate to Gaol Square and the tank is in Wolverhampton Road.

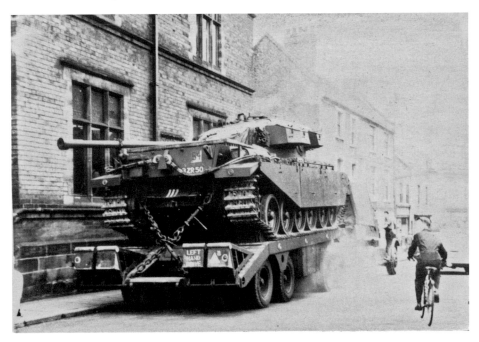

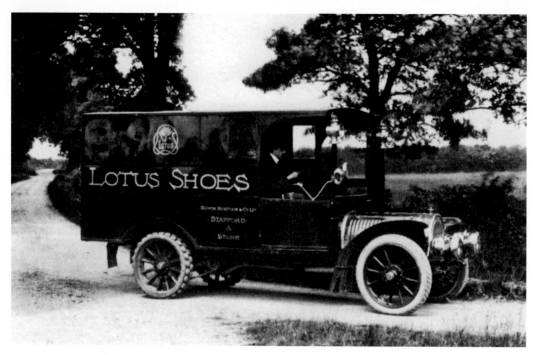

BOSTOCKS began making shoes in 1822. This is a delivery van *c.* 1912, advertising Edwin Bostock & Co's 'Lotus Shoes'.

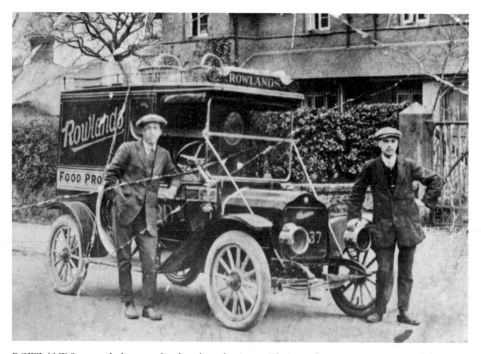

ROWLANDS ran a bakery and a butchers business. Their pork pies were renowned for their excellence.

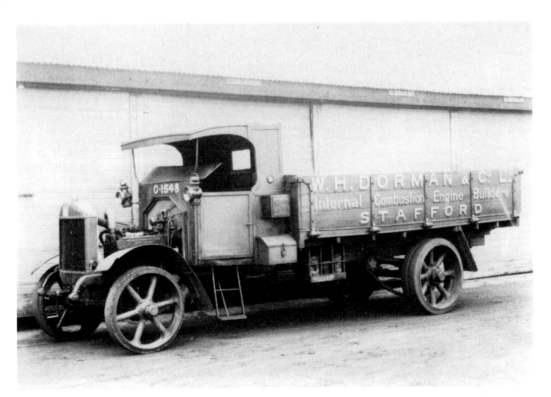

W. H. DORMAN LTD, originally founded to press knives for the shoe industry, turned to manufacture of internal combustion engines *c.* 1900. This lorry is pictured *c.* 1920.

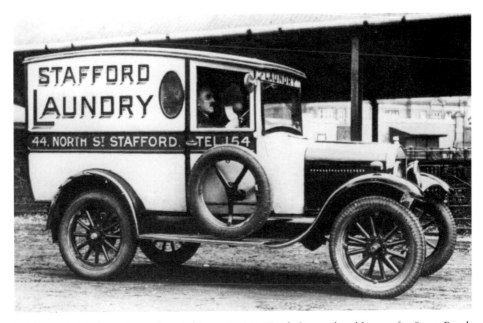

STAFFORD LAUNDRY was founded in *c.* 1902 in North Street, the old name for Stone Road. This van probably ran in the 1920s.

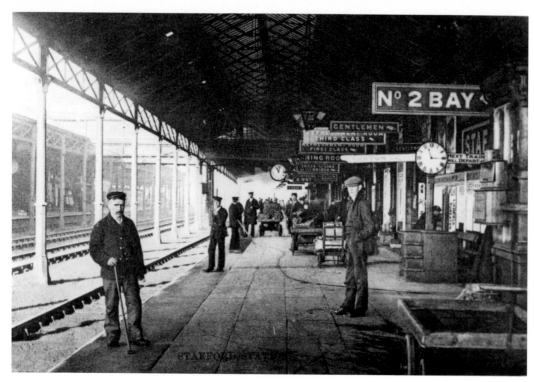

THE BUSY PLATFORM OF NO 2 BAY, STAFFORD STATION, c.1900. Mr. Green, station Chief Inspector (LMS), stands beneath the second clock.

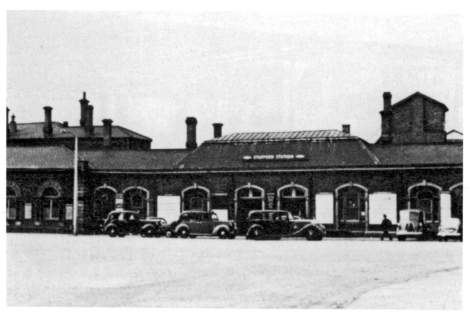

THE THIRD RAILWAY STATION AT STAFFORD, built in the 1860s. The Grand Junction Railway opened in Stafford in July 1837. This station was replaced by the present station in the early 1960s.

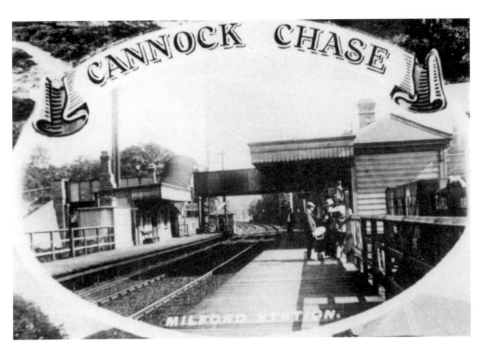

MILFORD, a small picturesque village in Cannock Chase, has long been a popular leisure area. A hundred years ago the favourite method of travel to it was by train to its small station.

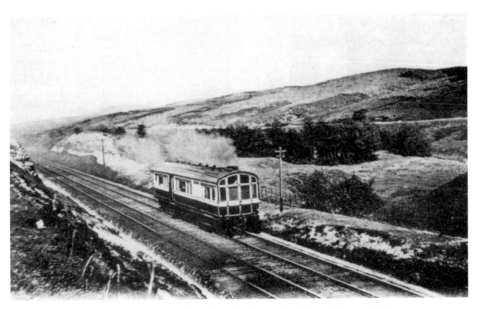

AN EARLY MOTOR TRAIN travelling through the lonely hills of Cannock Chase.

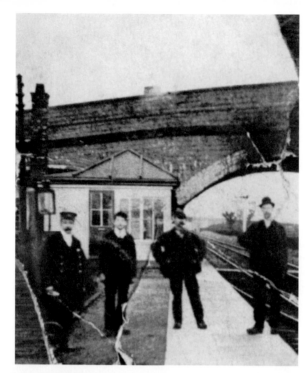

HAUGHTON STATION was on the Stafford-Wellington line. Both were closed by Dr. Beeching. Mr. Barnett (second from the right) was a plate layer. In bad weather he went 'fogging' i.e. laying fog signals.

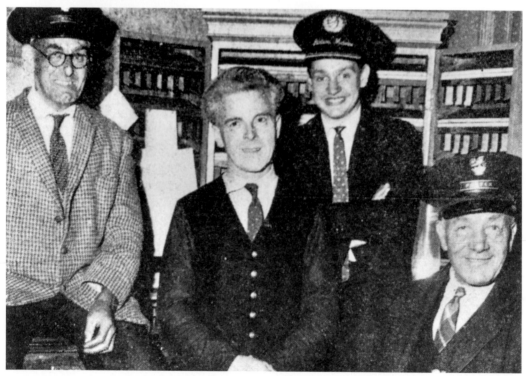

GNOSALL STATION was closed on 6 September 1964, also a victim of Dr. Beeching. The station staff are seen here in the closed booking office.

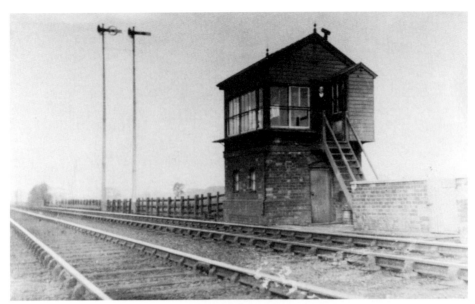

THE SIGNAL BOX AT GREAT
BRIDGEFORD was run for over
forty years by Thomas Whale,
seen here at the door of the box
and, right, with his bicycle.

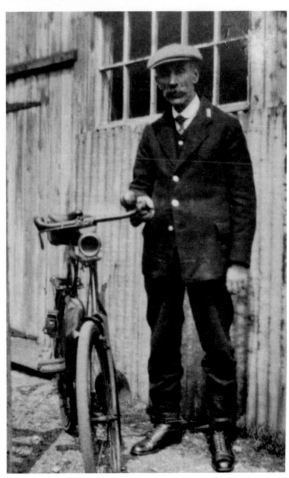

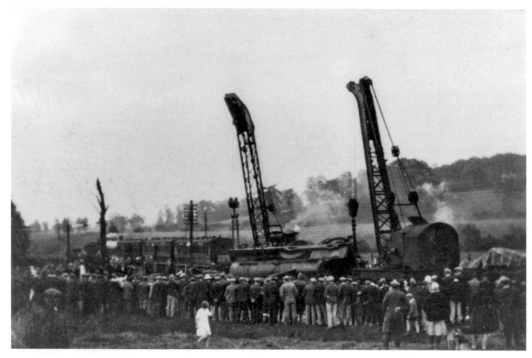

THIS ACCIDENT happened at Great Bridgeford in the early part of the twentieth century. The photographs were taken by the signalman on the previous page.

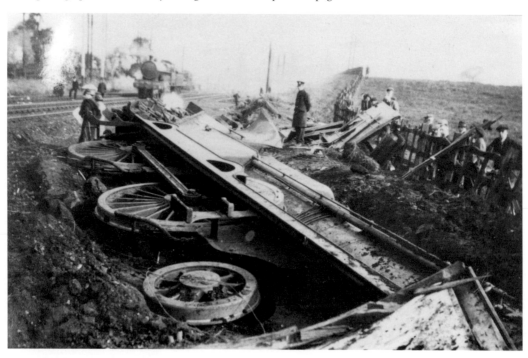

CHAPTER THREE

AT YOUR SERVICE

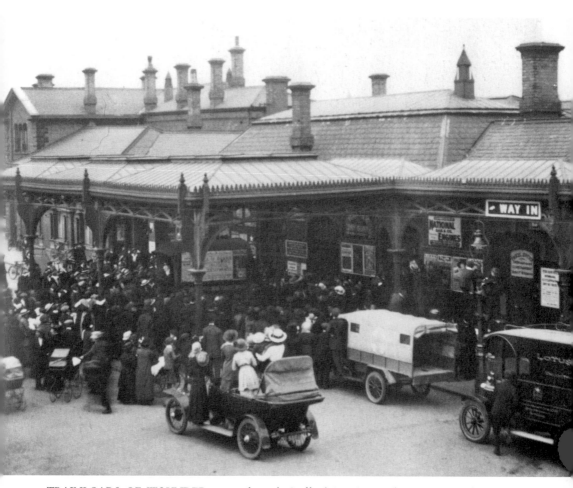

TRAINLOADS OF WOUNDED came through Stafford in 1915 and some were taken to Staffordshire General Infirmary. Local people used any transport they had to help out and many came just to have a word with the soldiers: 'We went home in tears for those young lads'.

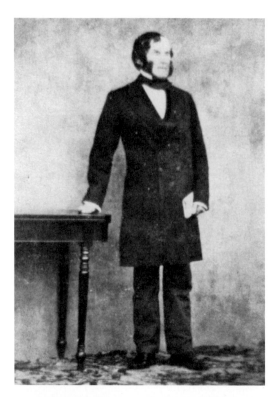

DR. EDWARD KNIGHT was a doctor at Staffordshire General Infirmary, photographed here in the 1860s. The Hospital was built in 1766.

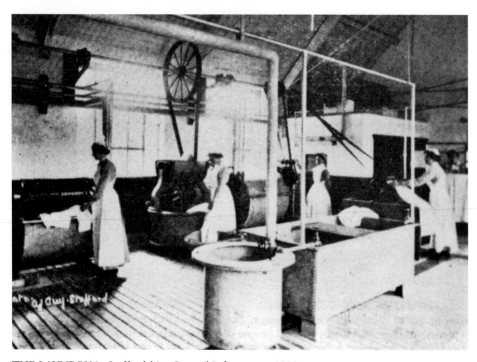

THE LAUNDRY in Staffordshire General Infirmary, *c.* 1900.

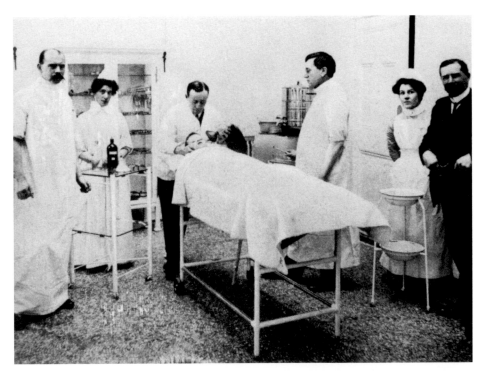

THE OPERATING THEATRE in Staffordshire General Infirmary, *c.* 1900.

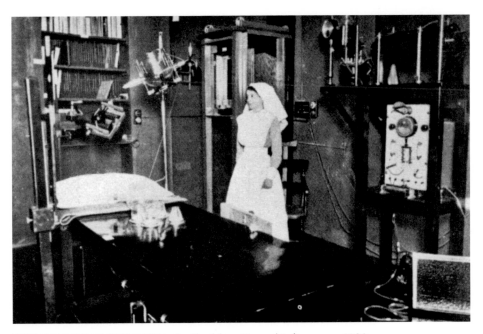

THE OPERATING THEATRE in Staffordshire General Infirmary, *c.* 1920.

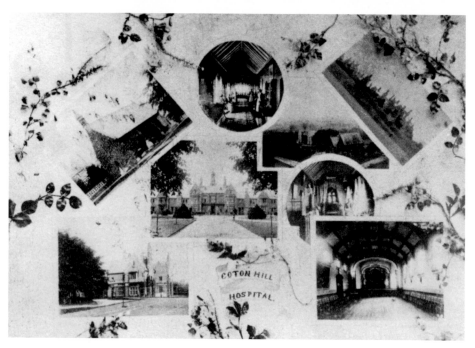

COTON HILL was a private mental hospital opened in 1854. It was self-sufficient, having its own farm and gardens.

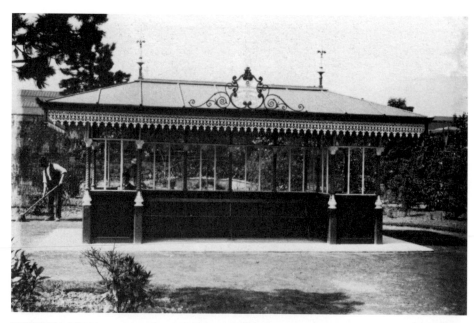

VICTORIA PARK was created in 1905 on an area of waste land next to the River Sow near the railway station. This iron shelter is still there and the park has given hundreds of Staffordiands much pleasure.

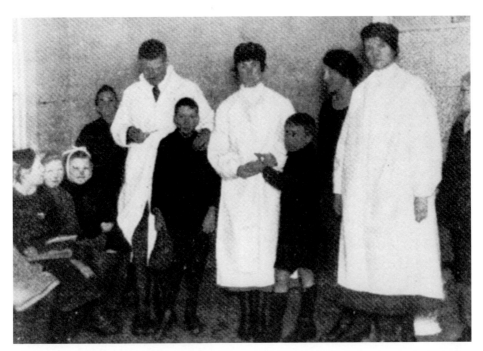

STAFFORD SCHOOL NURSES in 1928. They had to inspect heads for lice and check that children were being cared for properly.

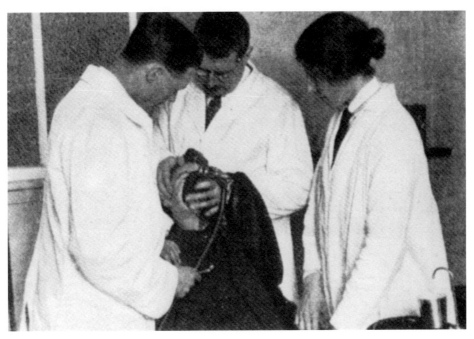

STAFFORD SCHOOL DENTISTS in 1928. However necessary, those visits were dreaded!

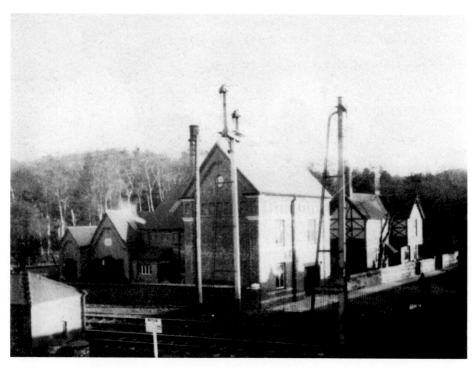

STAFFORD CORPORATION WATERWORKS PUMPING STATION erected at Milford in 1889.

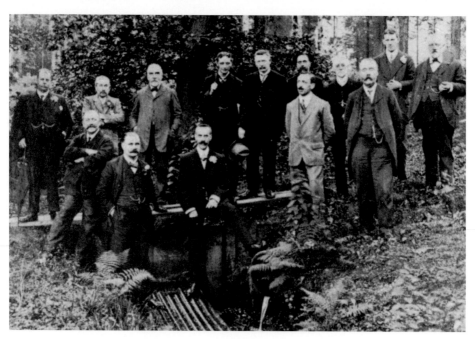

THE WATERWORKS COMMITTEE photographed near Milford Pumping Station in 1889.

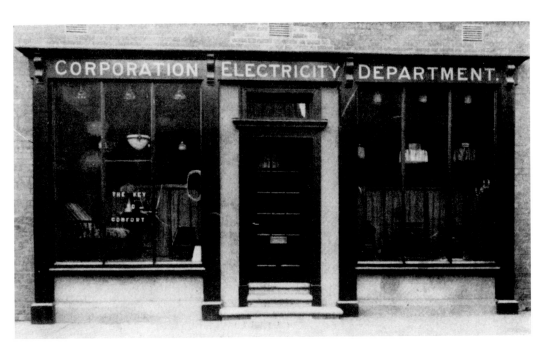

STAFFORD CORPORATION ELECTRICITY WORKS IN THE FOREGATE. When electricity was first brought to Stafford only six street lamps were erected and the old gas lamps were left *in situ* in case the new power did not work.

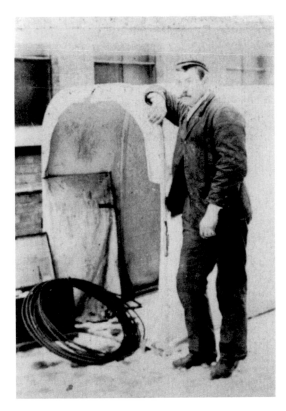

AN ELECTRICITY EMPLOYEE in Stafford at the turn of the century.

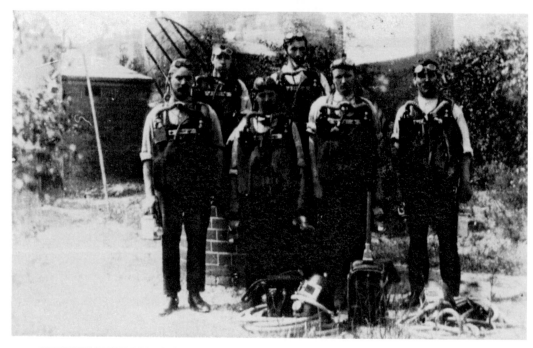

THESE HARDWORKING GENTLEMEN may be sewer workers judging by the equipment they are wearing.

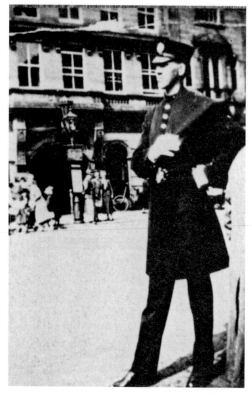

A POLICEMAN outside the old police station in Stafford, probably in the late 1920s or early '30s.

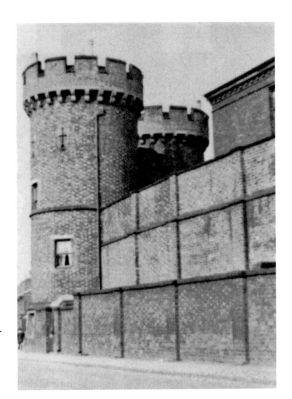

STAFFORD GAOL was built in 1793. These towers had to be taken down when they became unsafe probably due to brine pumping underneath Stafford for salt.

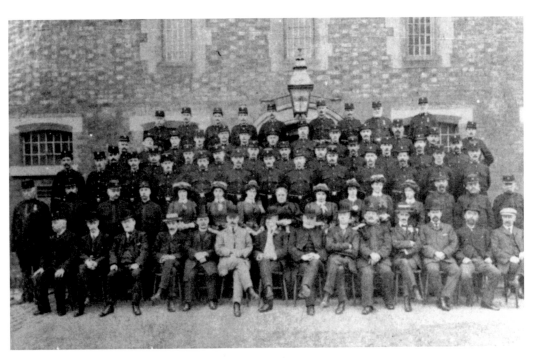

THE GOVERNOR AND STAFF OF STAFFORD GAOL, photographed *c.* 1890. Note the women staff- Stafford was a mixed prison for many years.

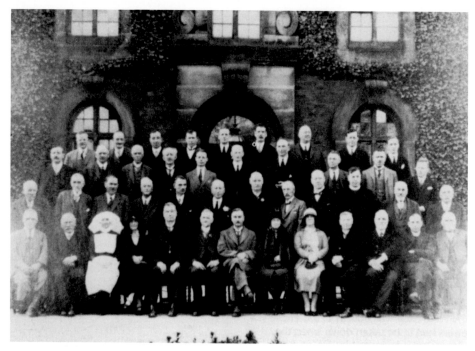

THE STAFFORD BOARD OF GUARDIANS at their last meeting in March 1930. George Horne was the chairman. Stafford Union Workhouse was in Marston Road and could hold 398 poor people.

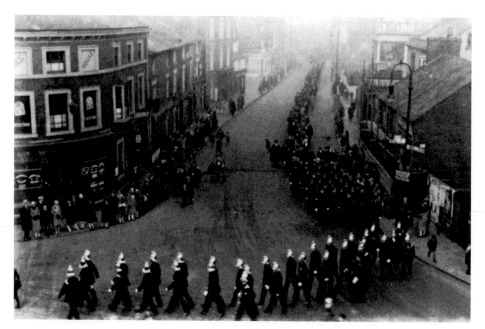

A PARADE OF LOCAL SERVICES probably in the 1920s.

CHAPTER FOUR

FISH, FRUIT
AND FRYING PANS

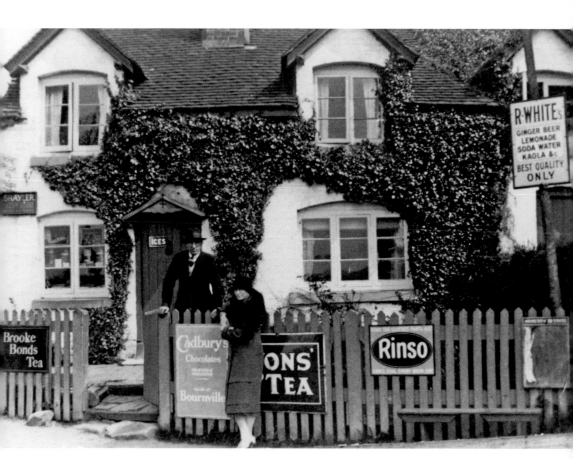

THE VILLAGE SHOP IN GREAT BRIDGEFORD in the 1920s.

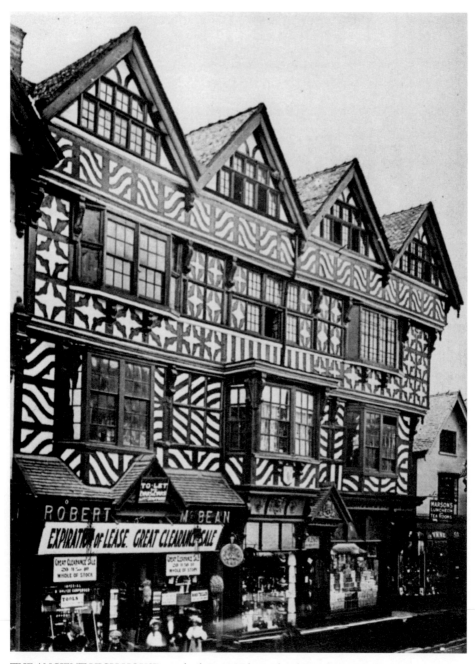

THE ANCIENT HIGH HOUSE was built in 1595 by Richard Dorrington. In the early nineteenth century shops occupied its ground floor. Robert McBean was an ironmonger and ammunition dealer until his lease ran out.

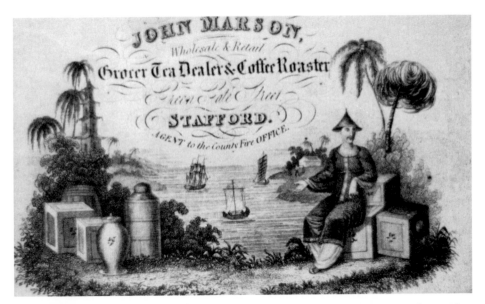

JOHN MARSON'S BILLHEAD. His shop was on the corner of the High House and was a fine grocer's shop.

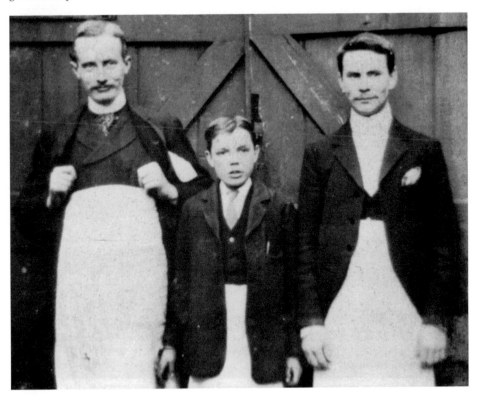

PONGO, SQUIB AND PAT - the names by which three of Marson's employees were known.

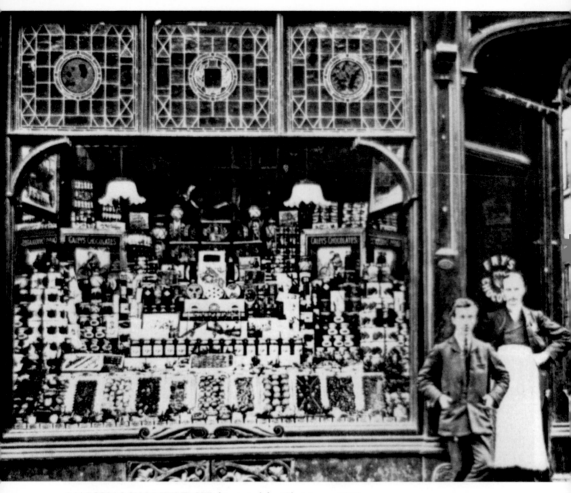

MARSON'S SHOP WINDOW decorated for Christmas, 1903.

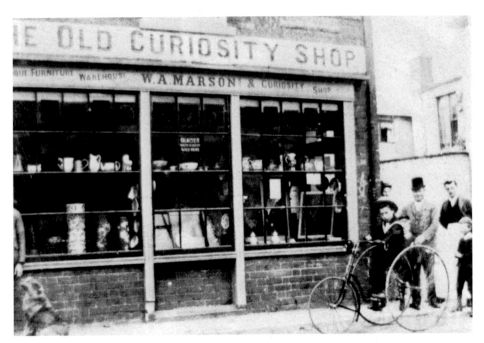

W. A. MARSON'S OLD CURIOSITY SHOP in Albion Place, *c.* 1880. William was a lay preacher in Stafford.

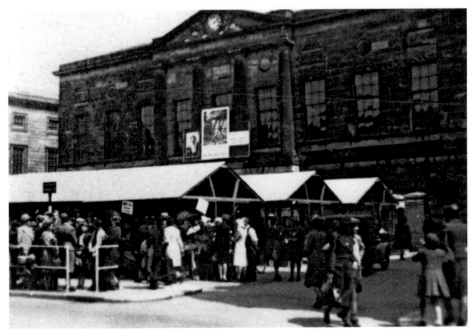

THE MARKET HALL IN STAFFORD was needed for wartime activities and the market was banished beack to the cobbles in the Square. The covered stalls are seen here in 1941.

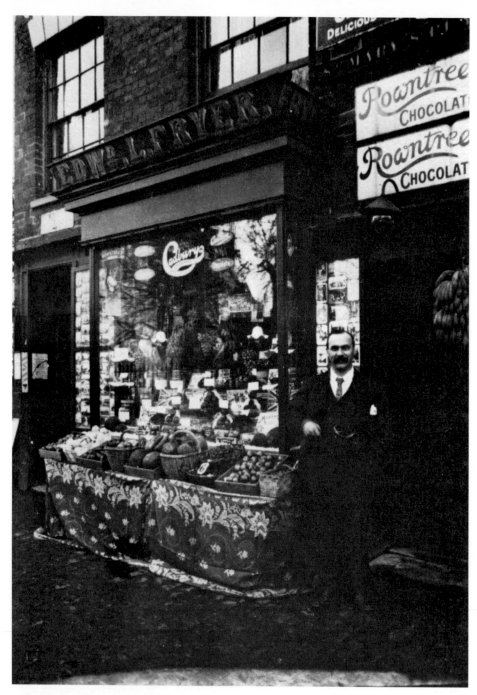

FRYER'S FRUIT SHOP in St. Mary's Place.

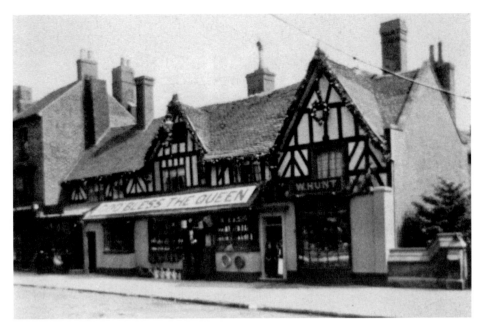

DALE'S OLD SHOP IN 1887 with a patriotic banner for the Queen's Golden Jubilee. This was a Tudor house which became an ironmonger's shop. A large brass kettle hung over the central gable, and in the fishing season it was joined by a rod and line.

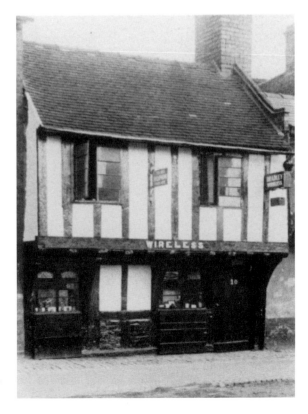

THIS SMALL TIMBERED HOUSE in Church Lane was used as a wireless shop in the 1920s.

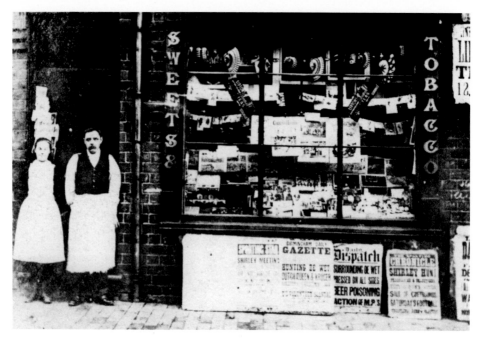

A TOBBACCONISTS AND NEWSAGENTS SHOP In Marston Road displaying headlines about the Boer War.

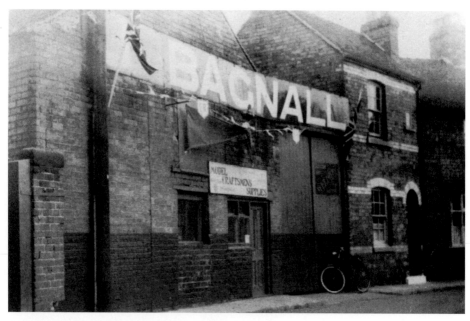

A MECCA FOR BOYS UP TO THE AGE OF EIGHTY. In 1936 John W. Bagnall's interest in sharing his hobby of model making led to the start of his model supply business in his father's coach-building works in South Walls. The firm moved to its present premises in 1964.

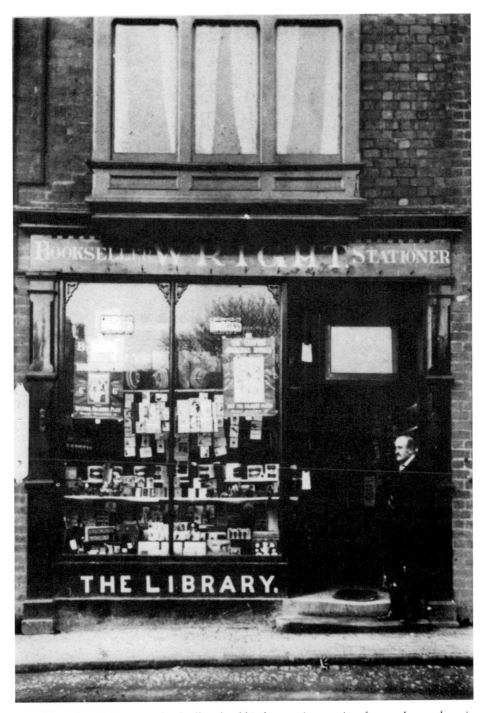

R. and W. WRIGHT , printers, booksellers, bookbinders, stationers, pianoforte and general music repository, could be found in Greengate Street in 1899.

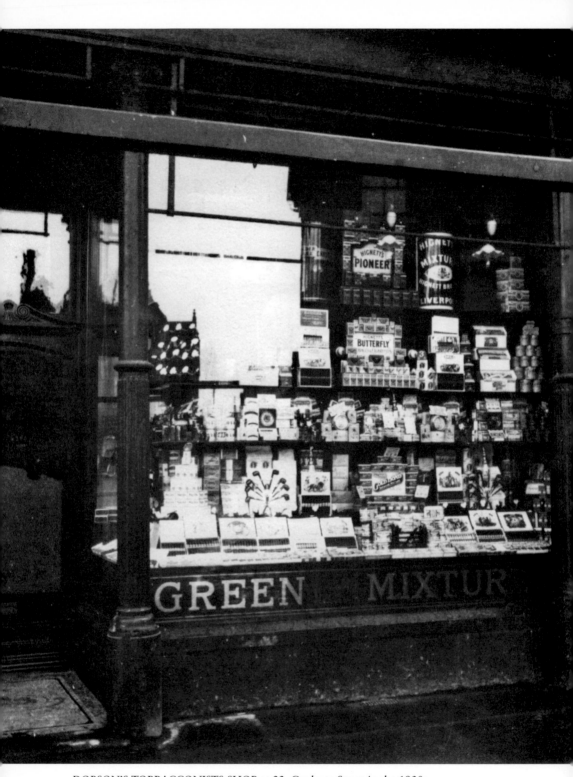

DOBSON'S TOBBACCONISTS SHOP at 22, Gaolgate Street in the 1930s.

CHAPTER FIVE

THE COMMON TASK

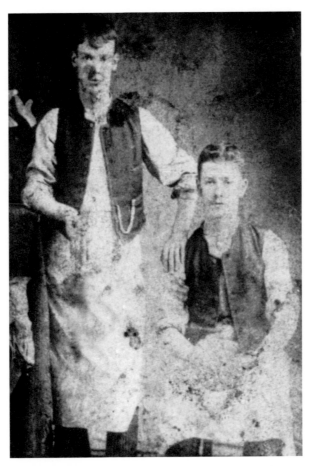

THE MANUFACTURE OF BOOTS AND SHOES was Stafford's principal industry during the nineteenth century. This photograph shows finishers at Edwin Bostock's shoe factory in the Foregate in the 1890s.

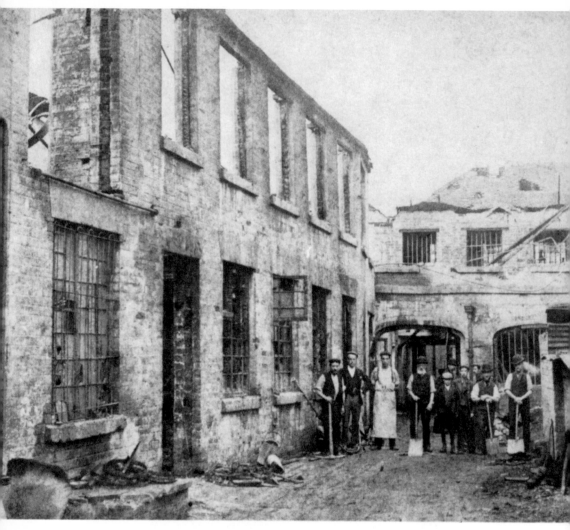

CLEARING UP THE DEBRIS following the fire at Edwin Bostock's in 1901, which resulted in the Sandon Road factory being built and opened in 1903.

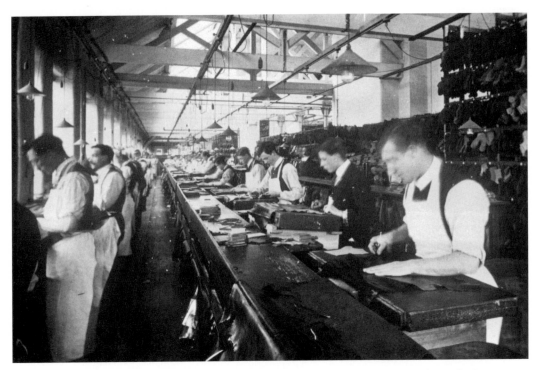

BOSTOCK'S, the largest shoe factory in Stafford, became Lotus Ltd in 1919. This is the Lotus clicking room during the 1920s.

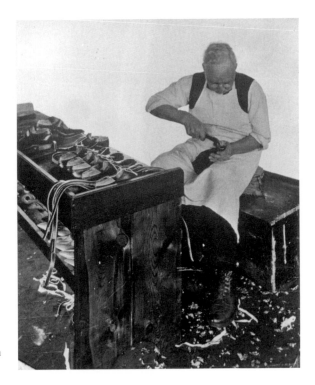

HANDLASTING at Lotus Ltd in the 1920s.

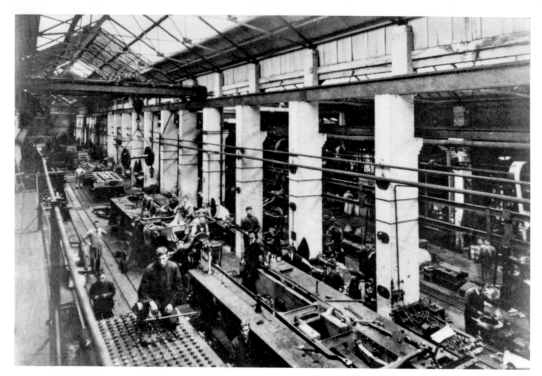

THE ERECTING SHOP at the Castle Street Work of W. G. Bagnall between the wars. In 1876
W. G. Bagnall built their first locomotive at these works.

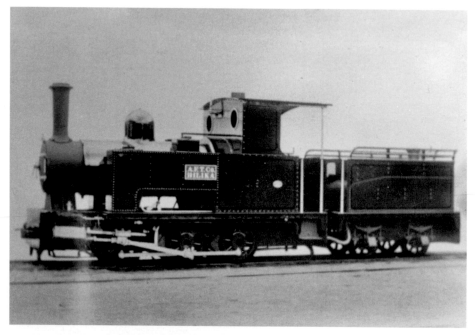

ONE OF BAGNALL'S TRADE CARDS.

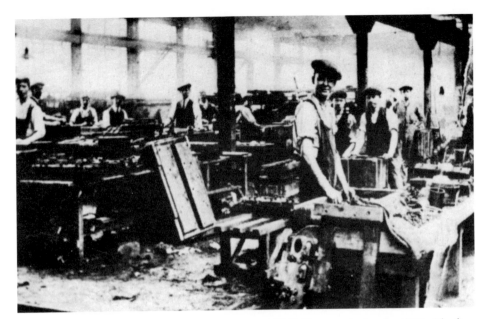

THE MEN'S CORE SHOP at the Stafford factory of W. H. Dorman during the 1930s. The firm was founded by William Henry Dorman, the son of a Stafford Congregational Minister in 1870. Diesel engines were produced from the late 1920s.

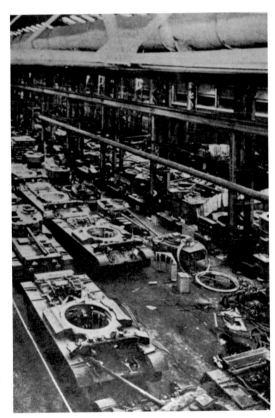

PRODUCTION OF CROMWELL TANKS AT ENGLISH ELECTRIC, formerly Siemens Bros. and Co., Stafford works, during the Second World War. The Stafford works made a major contribution to the war effort in tank manufacture.

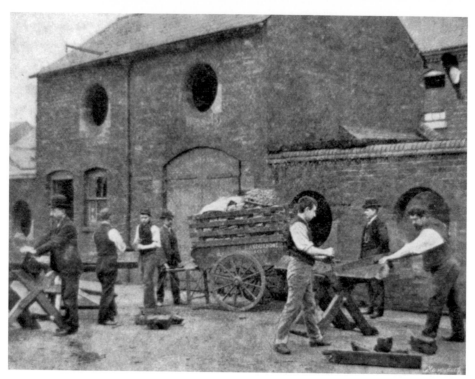

LICHFIELD DIOCESAN LABOUR HOME was in Austin Friar Street. It was established in 1891 for 'unfortunate men out of work who have fallen low, retaining them for two or three months that they may recover their character and find employment'.

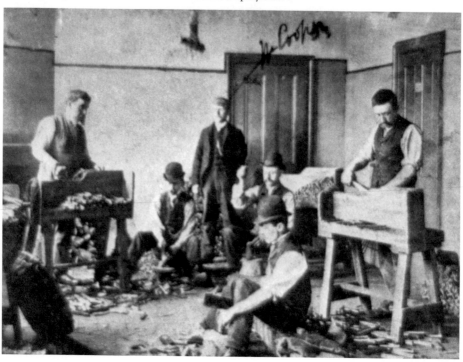

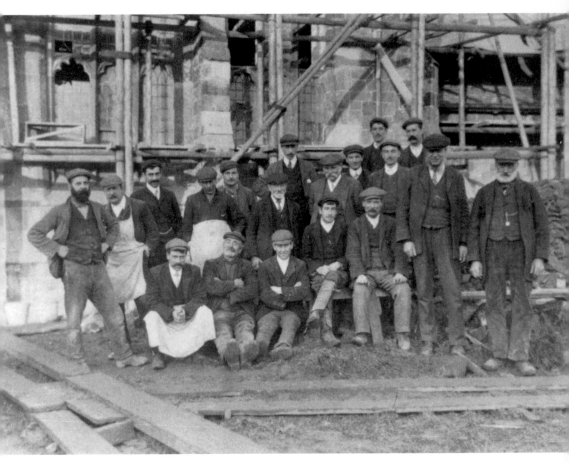

WORKMEN employed in the restoration of Bradley church in 1907.

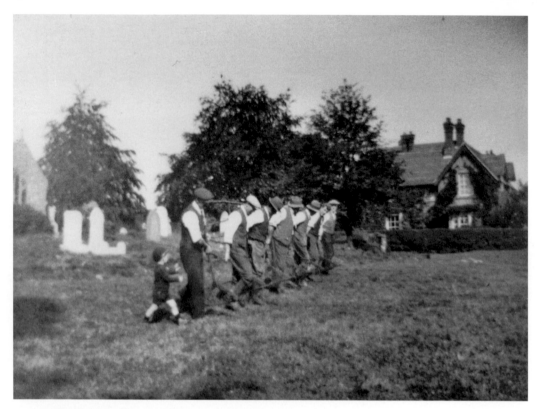

BRADLEY CHURCH COUNCIL moving the churchyard railings in 1922.

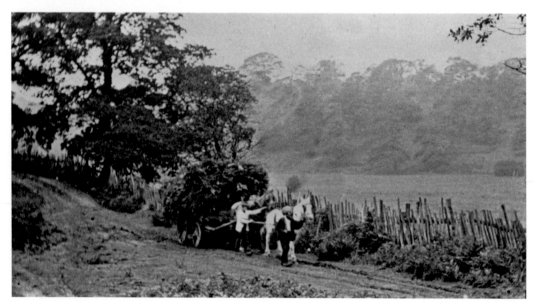

HARVESTING THE CHASE *c.* 1905.

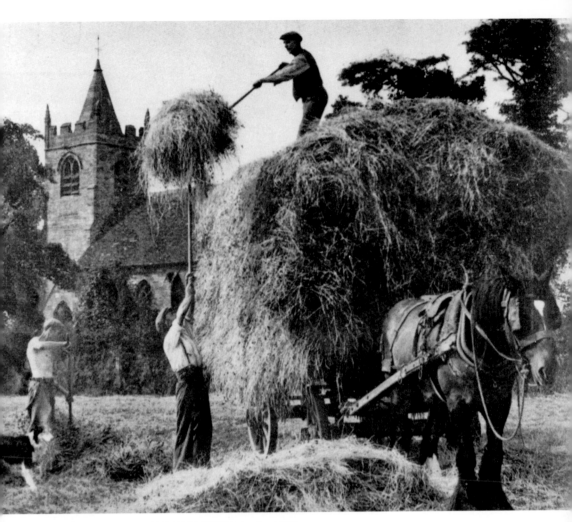

HARVESTING AT ACTON TRUSSELL in the 1950s.

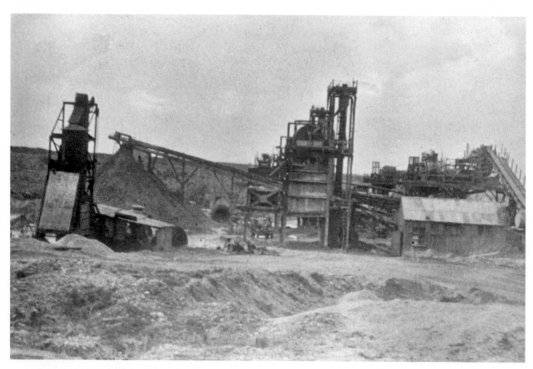

BROCTON GRAVEL WORKS, an undated photograph.

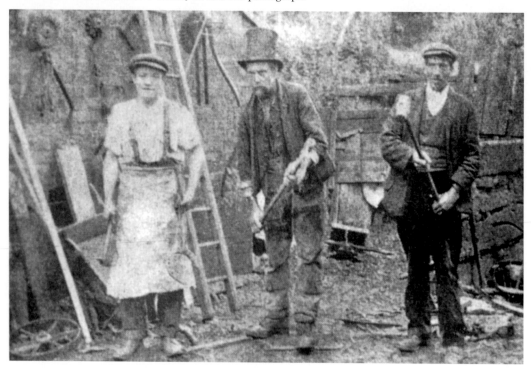

HAUGHTON SMITHY. The photograph is difficult to date, but the dress of the man in the middle suggests it is well before 1900.

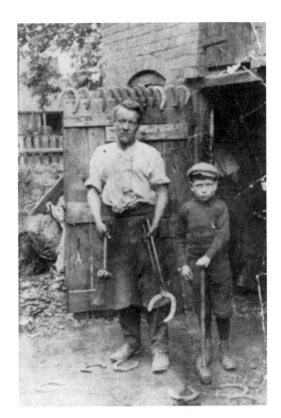

THE SMITHY AT HAUGHTON early
last century.

A FARMER at Hopton in 1910.

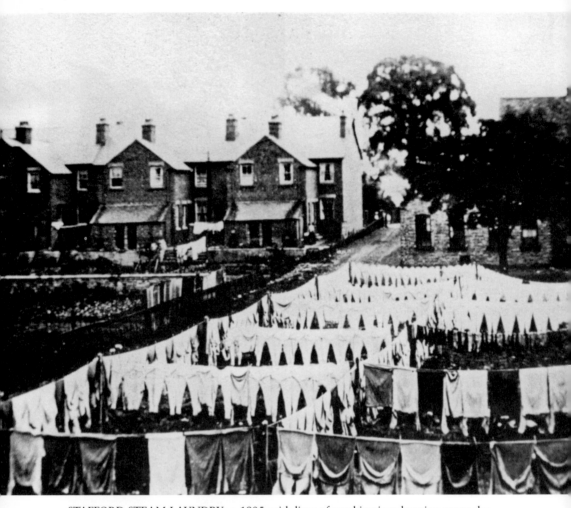

STAFFORD STEAM LAUNDRY, *c.* 1905, with lines of combinations hanging out to dry.

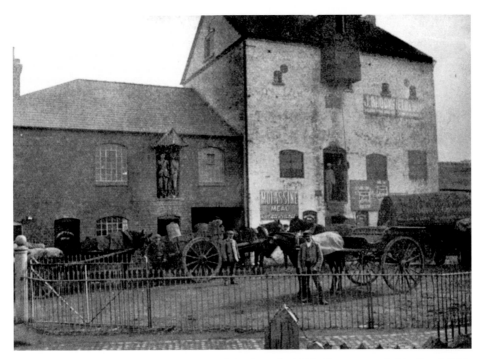

STAFFORD TOWN MILL, TENTERBANKS, in the early 1900s. It was occupied by Brookfields who produced animal feed. The mill was demolished in 1957.

WILLIAM SALT LIBRARY, EASTGATE STREET. The maid, Ellen Merricks, is pictured in January 1934. Until 1984, the library was home to its librarians as well as its books.

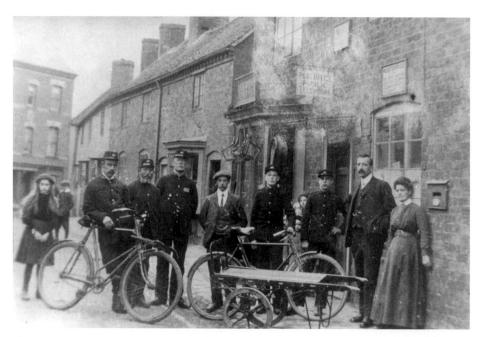

THE STAFF AT GNOSALL POST OFFICE in 1910. Alfred Yates was the sub-postmaster.

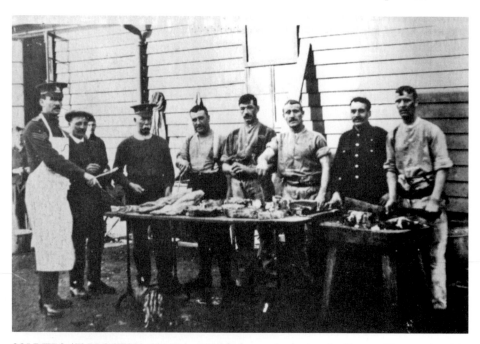

SOLDIERS AT BROCTON CAMP in 1915 before embarkation for France. First on the right is George Hill from Rugeley, 2nd Battalion North Staffs Regiment. His wife also worked at the camp doing sewing repairs.

CHAPTER SIX

COTTAGES AND CASTLES

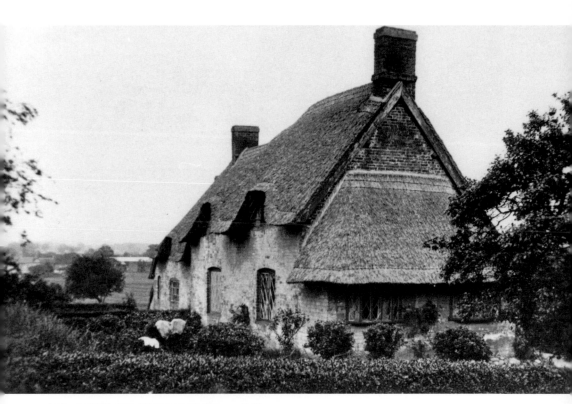

OLD COTTAGES AT ELLENHALL, *c.* 1900.

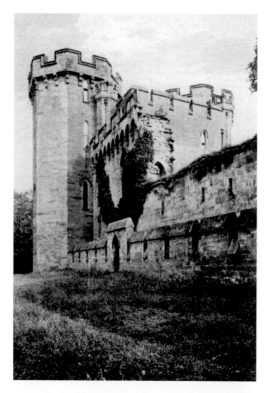

STAFFORD CASTLE built between 1810 and 1815 by Sir George Jerningham, 1st Baron Stafford, on the foundations of the medieval castle and site of the Norman fortress. It was never completed.

LORD STAFFORD at the castle in 1933.

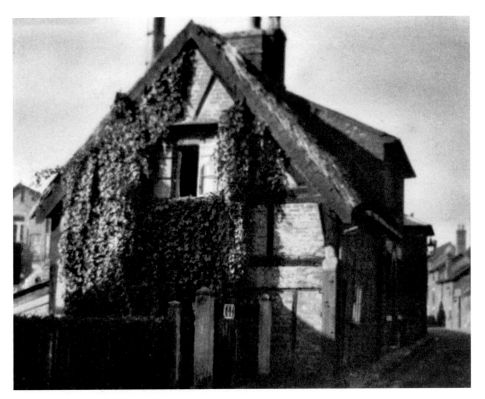

No.82 SOUTH WALLS, Stafford, 1936.

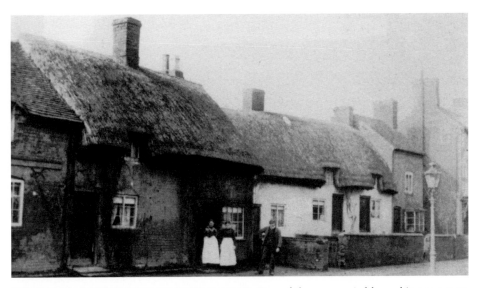

THATCHED COTTAGES IN LICHFIELD ROAD. One of these, occupied by a chimney sweep, was destroyed by fire.

ST. MARY'S OLD RECTORY, 21,
Greengate Street, *c*. 1860.

NO. 23, GREENGATE STREET, opposite the Post Office, *c*. 1900.

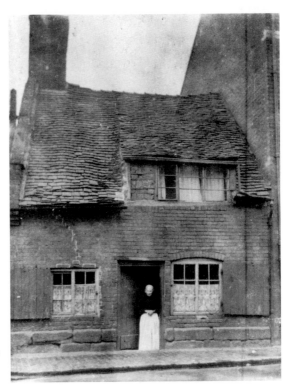

COTTAGE IN EASTGATE STREET,
formerly on the site of the present
police station, 1908.

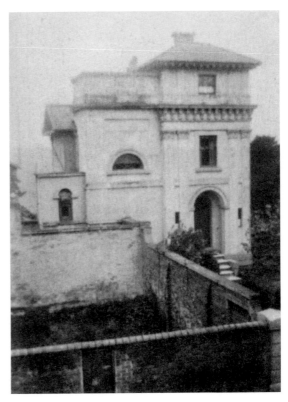

THE ITALIAN VILLA. Foregate
Street, in 1922. It was demolished
in 1935.

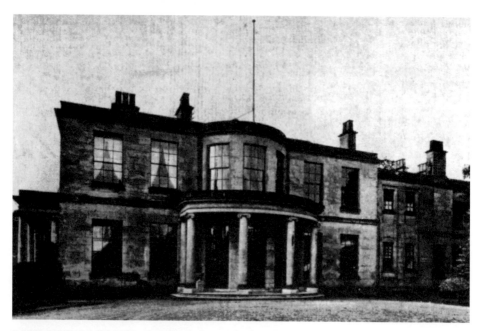

ROWLEY HALL IN 1928. 'An elegant house' built in 1817, it became a remand home for girls in the 1930s. It is now a private hospital.

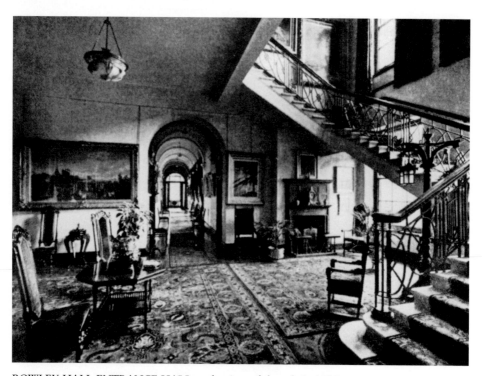

ROWLEY HALL ENTRANCE HALL at the time of the sale in 1928.

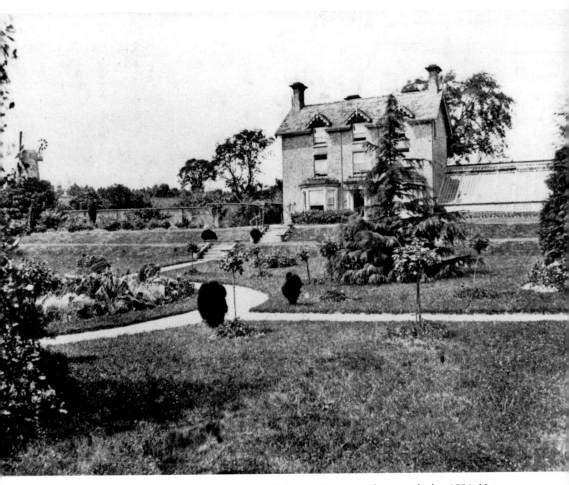

THE HOME OF WILLAM MARSON, Butterhill House, Dunston, photographed *c.* 1891. Note the windmill in the background.

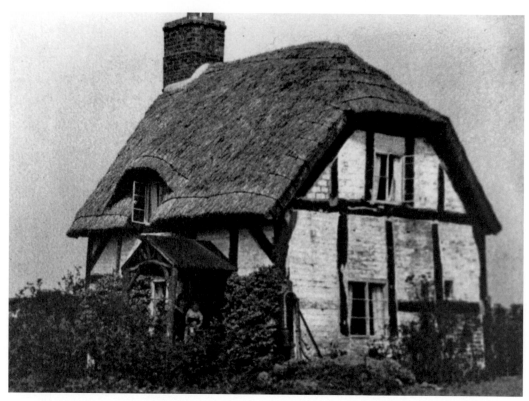

FIELDSIDE COTTAGE, Haughton, *c.* 1937.

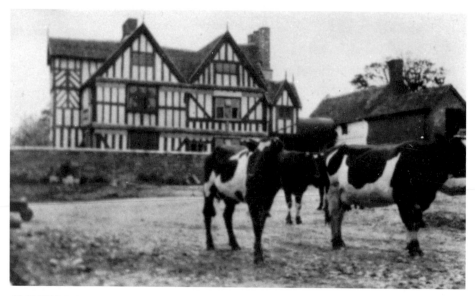

CLANFORD HALL near Seighford pictured *c.* 1930. It is believed to be the birthplace of Revd. William Wollaston, a philosophical writer, in 1659.

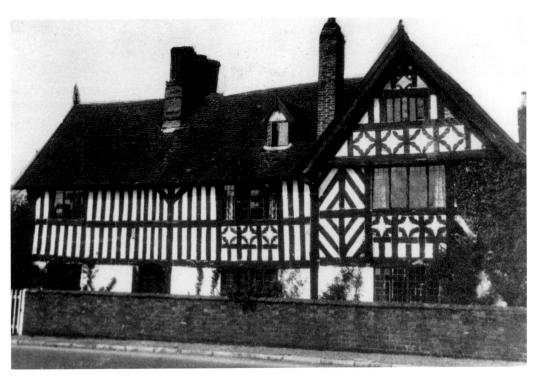

HAUGHTON HALL, a fine, timbered house, built in the late sixteenth century and photographed here in 1937.

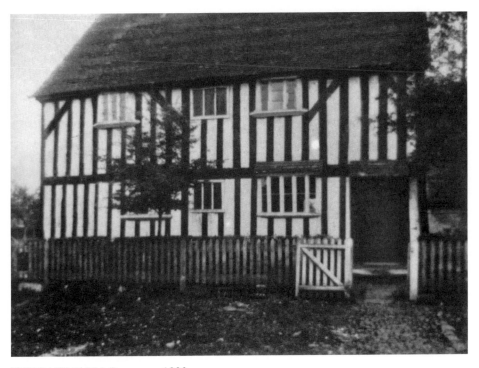

VICARAGE FARM, Ranton, *c.* 1930.

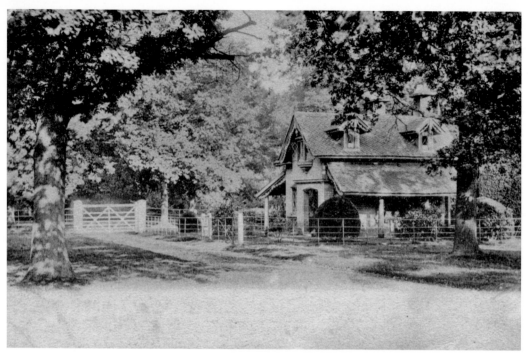

THE LODGE TO RANTON ABBEY, *c.* 1903.

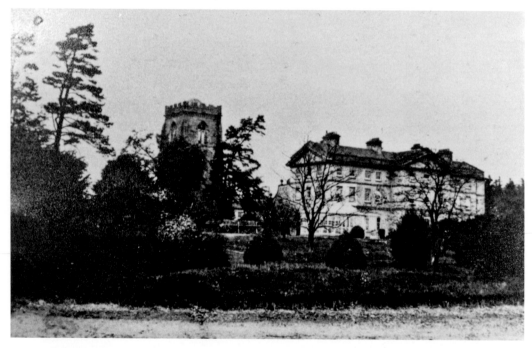

RANTON ABBEY, *c.* 1928. The remains of the priory of Augustinian Canons stand next to the eighteenth-century country house, acquired by the Anson family in 1817 as a shooting lodge. Recquisitioned by the War Office, it was badly damaged by fire in 1942. The Earl of Lichfield re-purchased the house.

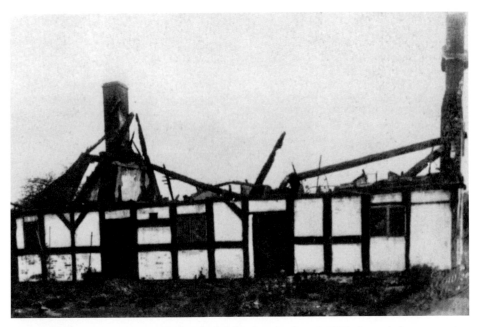

IZAAK WALTON's cottage at Shallowford following the fire of 1927. A spark from a passing steam train set the thatched roof on fire.

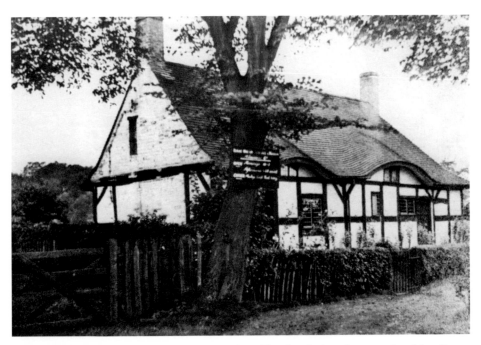

THE COTTAGE FOLLOWING RESTORATION. The thatched roof was replaced by tiles to avoid the possibility of a similar accident. Now, in the days of electric trains, the thatched roof has been restored.

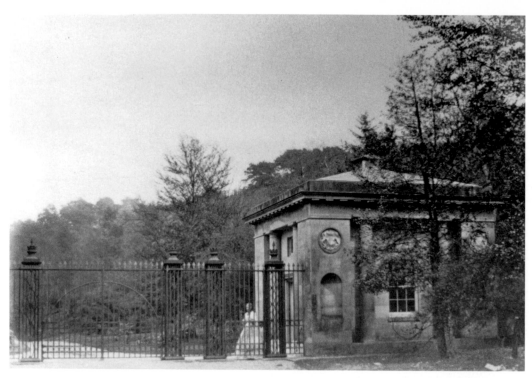

ONE OF THE MILFORD LODGES AT SHUGBOROUGH HALL, photographed in 1863. The lodges were designed by Samuel Wyatt, *c.* 1790-1806.

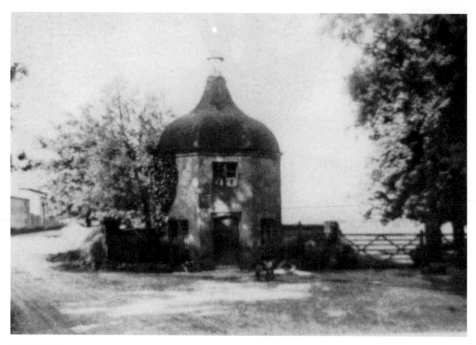

THE BOTTLE LODGE, Tixall, occupied as a home until 1927. The last inhabitant was Mrs. Ann Statham.

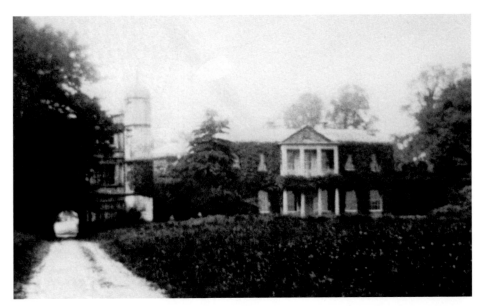

TIXALL HALL, built originally in 1555 and replaced by this mansion in 1782. The fine Elizabethan gatehouse served as a prison to Mary, Queen of Scots, and is now a holiday property.

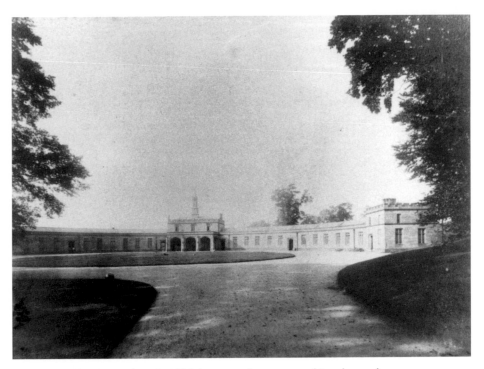

TIXALL STABLES, seen here in 1885, have now been convertd into luxury homes.

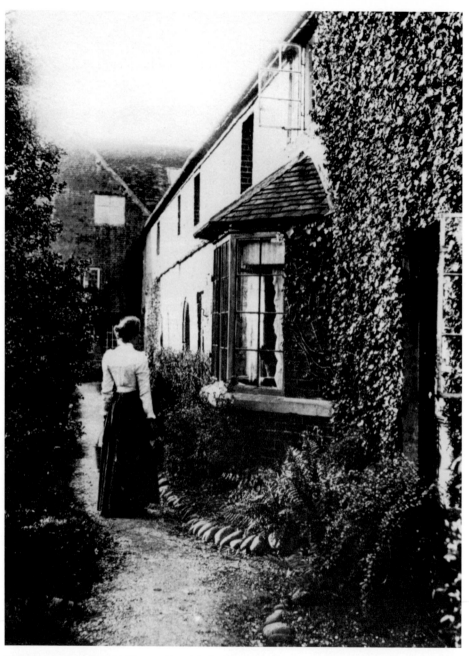

ST.THOMAS' MILL FARM, near Baswich, in 1910. The farm is on the site of St. Thomas' Priory. The lady in the photograph is Mrs. May Johnson.

CHAPTER SEVEN

UNWILLINGLY TO SCHOOL

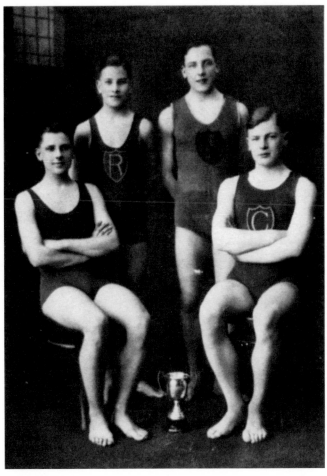

SWIMMING TEAM, King Edward VI's Grammar School, Stafford,
c. 1914.

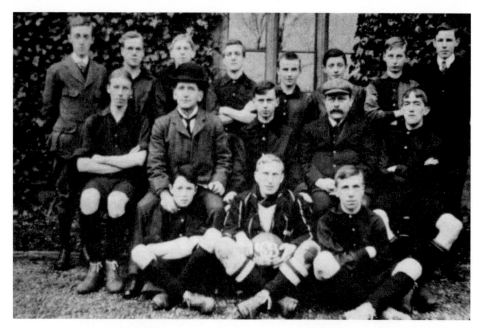

KING EDWARD VI'S FOOTBALL TEAM, 1912/13. Left to right, back row: T. Evans, T. Wilkes, C. Collier, W. Thornton, W. Wharmby, A. Smith, A. Venables, G. Taylor; centre row: C. Woodger, E. Powell, C. Arrowsmith, R. Lambert, S. Machin; front row: H. Stacey, F. Caton, M. Turner.

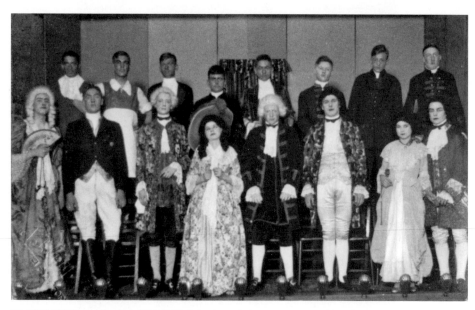

PRODUCTION OF *SHE STOOPS TO CONQUER* at King Edward VI's Grammar School, *c*. 1929.

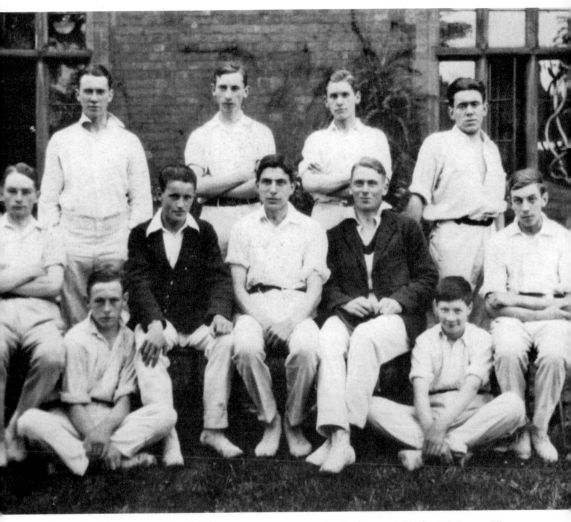

KING EDWARD VI'S CRICKET TEAM, 1927. Left to right, back row: ? Riseley, W. Scrase, W. Lloyd, J. Benton; centre row: G. Boon, A. Balmforth, N. Price, C. Averill, J. Thompson; front row: A. MacDonald, R. Blower.

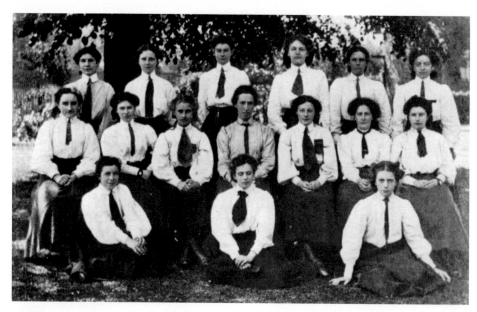

STAFFORD GIRLS HIGH SCHOOL. The sixth form 1908/9. Left to right, back row: M. Ridge, D. Bagnall, V. Bostock, P. Lodge, A. Colclough, C. Ashton; centre row: H. Eades, M. Law, M. Wheeldon, Miss Stone, J. Holloway, G. Wilks, H. Dutton; front row: M. Horton, H. Jennings, J. Moncur.

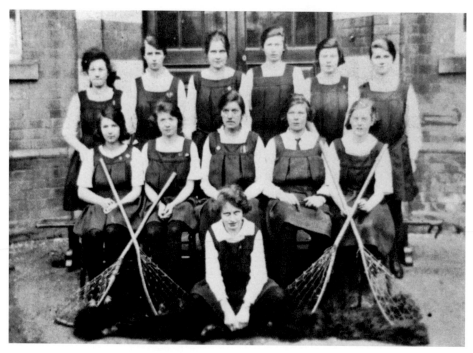

THE HIGH SCHOOL LACROSSE TEAM, 1922.

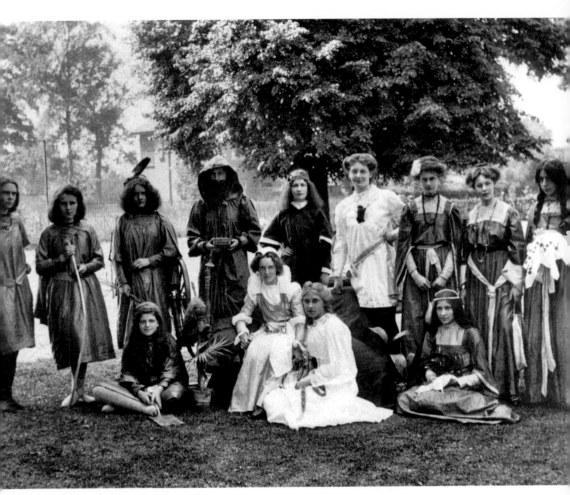

DRAMATIC PRODUCTION at the Girls High School in the early 1920s.

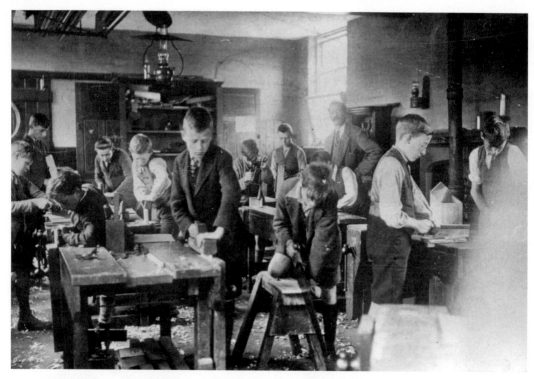

CARPENTRY CLASS at Gnosall National School, *c.* 1905.

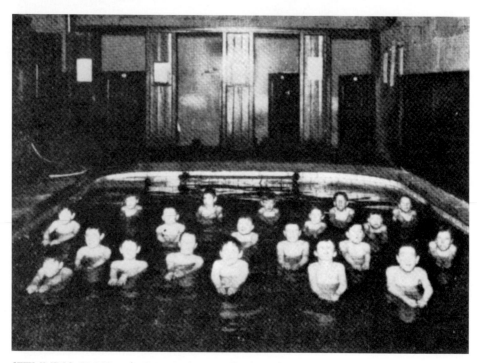

SWIMMING CLASS at the Brine Baths in Stafford in 1928.

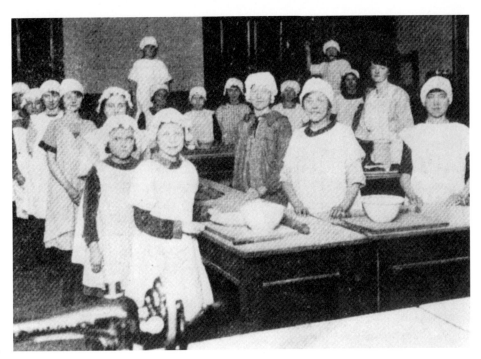

COOKERY CLASS at a Stafford school in 1928.

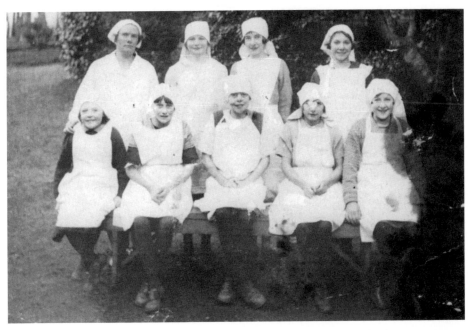

DOMESTIC SCIENCE GROUP at Marston Council School *c*. 1924. This school was in existence for only a few years in the 1920s.

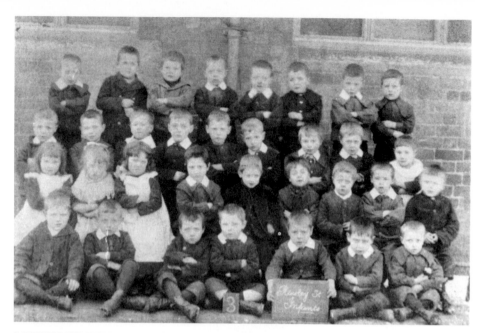

ROWLEY STREET INFANTS SCHOOL, Stafford, *c.* 1895.

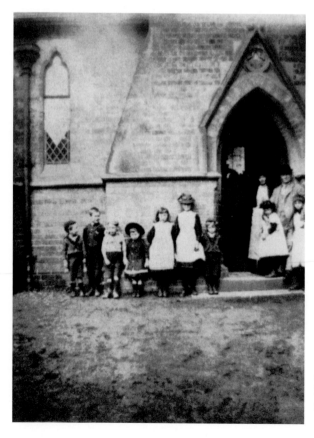

CHILDREN OUTSIDE
LITTLEWORTH SCHOOL
shortly after it was opened in
1885.

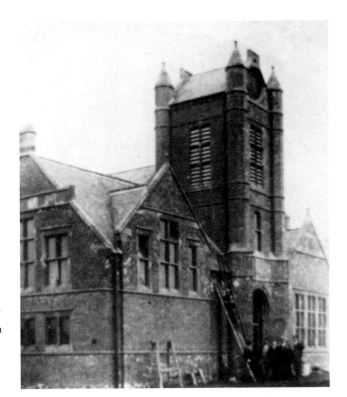

CORPORATION STREET
BOARD SCHOOL, built in
1895. The first master was
John Wheeldon and today
the school is named after
him.

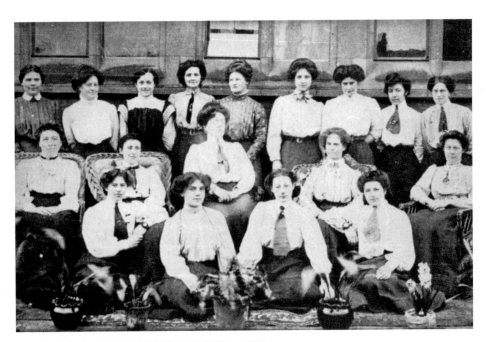

TEACHERS AT CORPORATION STREET in 1905.

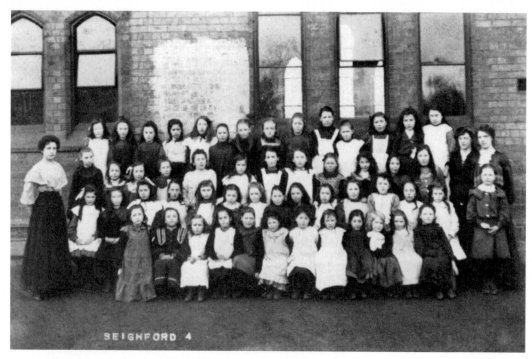

THE GIRLS CLASS at Seighford Council School in 1910. The school was built as a board school in 1874.

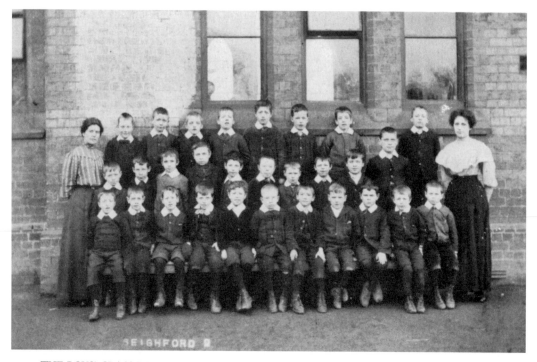

THE BOYS' CLASS IN 1910.

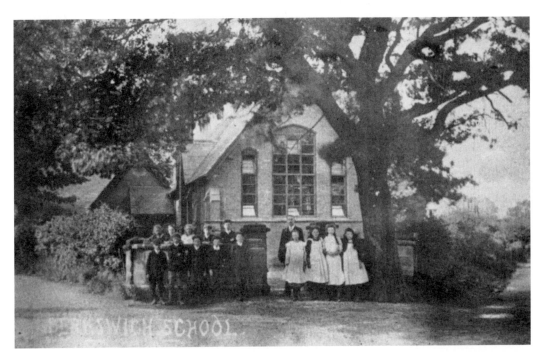

BERKSWICH SCHOOL, Walton, *c.* 1910.

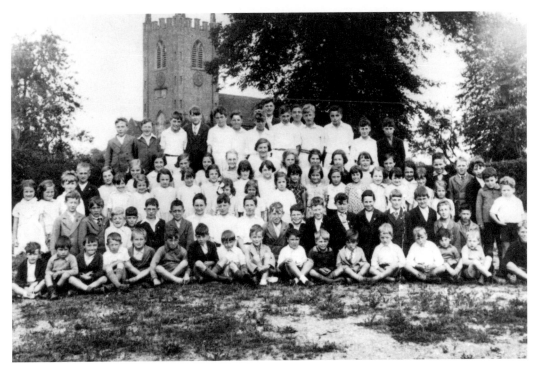

SEIGHFORD COUNCIL SCHOOL in 1937.

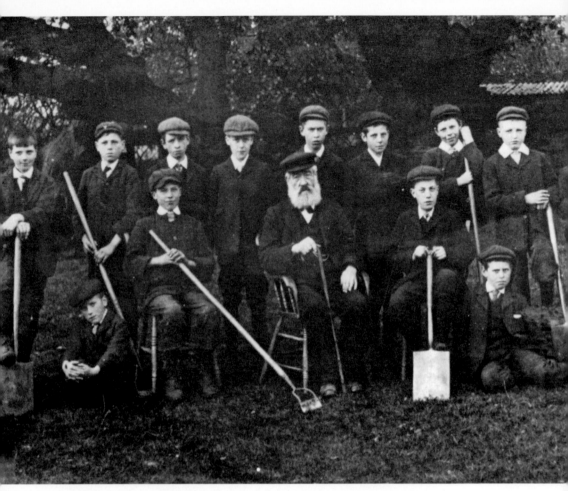

THE BOYS' GARDENING CLASS at Seighford School in 1912. The class was taken by Mr. Plant, the headmaster's father.

BROCTON DAME SCHOOL. In 1871 twelve children attended this school.

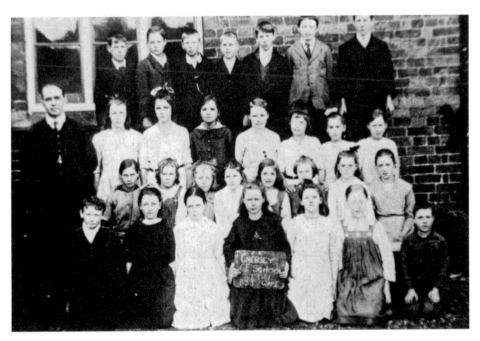

CHEBSEY CHURCH OF ENGLAND SCHOOL in 1921.

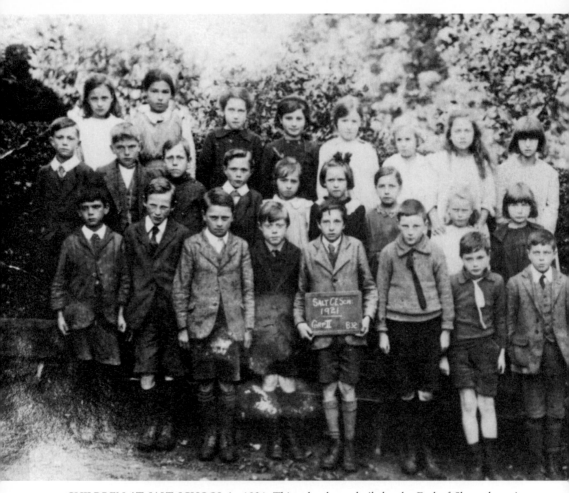

CHILDREN AT SALT SCHOOL in 1921. This school was built by the Earl of Shrewsbury in memory of his daughter, Lady Victoria Susan Talbot, who died in 1856.

CHAPTER EIGHT

PLEASURABLE PASTIMES

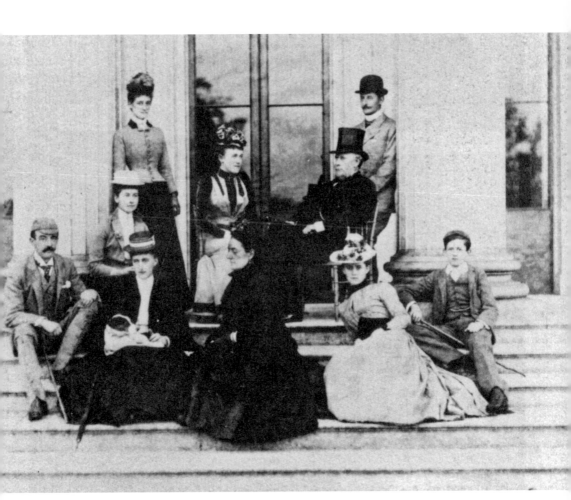

SERVANTS FORM RANTON ABBEY, the Earl of Lichfield's shooting lodge, on a visit to Shugborough in 1863.

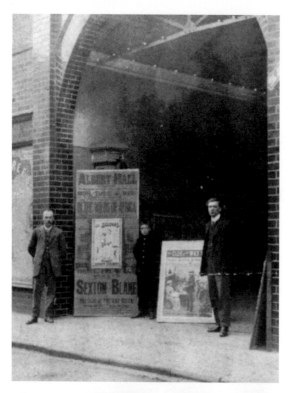

THE ALBERT HALL, Crabbery Street, opened as a cinema in May 1912 and closed in 1915. It reopened as a theatre in 1919. In 1932 it became a cinema once again, finally closing in 1952 to make way for the Co-operative Stores.

THE SANDONIA THEATRE, Sandon Road, opened in 1920 with a production of *Chu Chin Chow*. It never really succeeded as a theatre and struggled as a cinema until it closed in the mid-1960s.

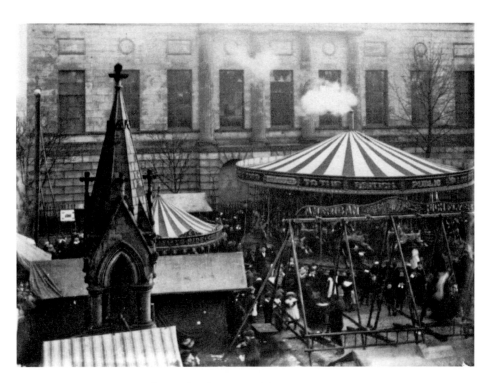

THE DECEMBER FAIR in the Market Square in 1906.

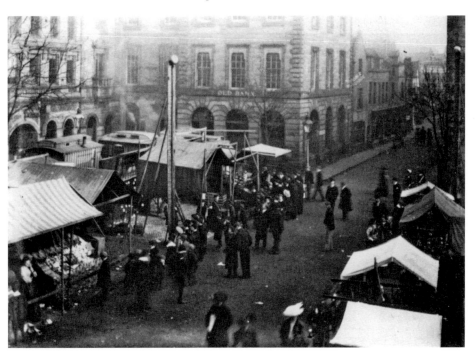

TAKING TEA at Halfhead Farm, Shallowford, in the 1920s.

THE OPENING OF THE AMERICAN TEA at Coton House, Gnosall, in *c.* 1919.

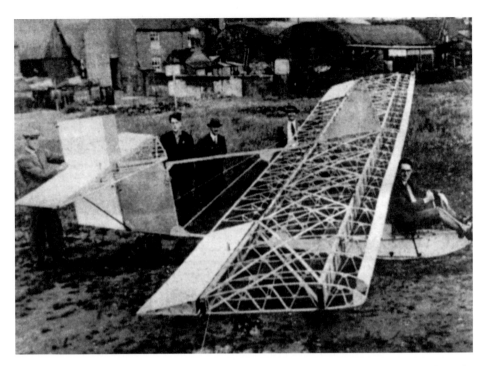

THIS GLIDER was built by John William Bagnall in the late 1930s. It became a popular sight in Stafford.

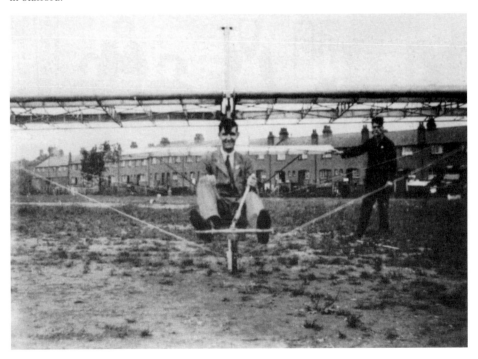

ST THOMAS' CHURCH SOCIAL CLUB at Castletown in the early 1950s produced several concerts which ran for three nights each and played to packed houses.

MARY HOLLYHURST produced this one-act play for the Social Club in 1952.

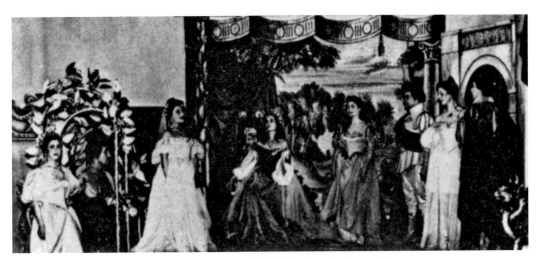

PURCELL'S OPERA *Dido and Aeneas* was produced at Ingestre Hall in 1957.

Dido and Aeneas

AN OPERA

The words by Nahum Tate
The music by Henry Purcell

Edited by Edward J. Dent

Cast in order of appearance:

Dido, Queen of Carthage	Magda Laszlo (*Hungarian*)
Belinda, lady-in-waiting to Dido	Adèle Leigh (*English*)
Aeneas, a Trojan Prince	Bernhard Sönnerstedt (*Swedish*)
First Lady	Belva Boroditsky (*Canadian*)
Second Lady Doreen Murray (*English*)
Sorceress	Monica Sinclair (*English*)
First Witch Silvia Beamish (*English*)
Second Witch Janet Baker (*English*)
Mercury	David Holman (*Canadian*)
Sailor	Alexander Young (*English*)

Conductor: JOHN PRITCHARD

Producer: ANTHONY BESCH

Designer: PETER RICE

ROYAL LIVERPOOL PHILHARMONIC ORCHESTRA
(*Leader:* Peter Mountain)

The Chorus selected and trained by
PETER GELLHORN

Dances arranged by KAREN BLISS

Continual: GEOFFREY PARSONS, *Harpsichord*;
DENIS VIGAY, *'Cello*

The Story of the Opera

Dido, Queen of Carthage, though much in love with Aeneas, Prince of Troy, fears the consequences of yielding to her passion, but her maid, Belinda, succeeds in persuading her to accept Aeneas as her consort. A Sorceress, jealous of the Queen's happiness, conspires with her accomplices to part the Royal lovers. Together they seduce the loyalty of the Trojan sailors and conjure up a spirit disguised as Mercury, who reminds Aeneas that he is bound by Fate to sail onwards to found a new Troy on the shores of Italy. Aeneas regretfully obeys the spirit and leaves Dido, who, broken-hearted at the loss of her lover, takes her own life.

115

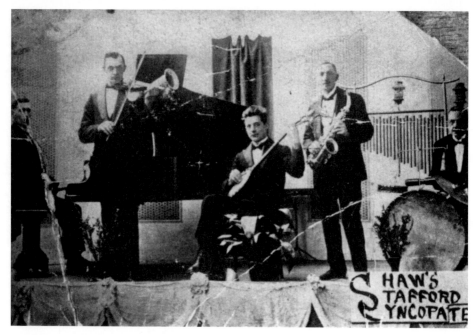

SHAW'S STAFFORD SYNCOPATERS pictured during the 1920s. Cyril Newbold, second from left, playd the Phonefiddle.

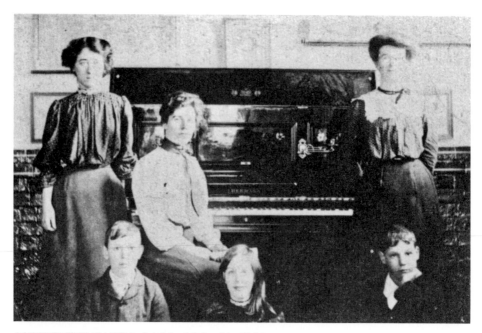

AROUND THE PIANO in Seighford School in 1906.

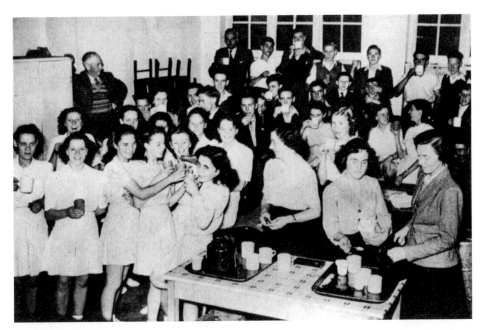

HOMECROFT YOUTH CLUB, Stafford, on a club night in 1947.

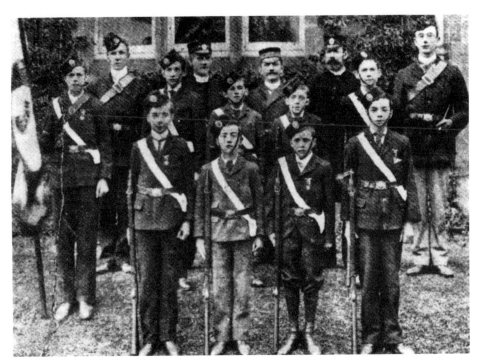

ST. THOMAS' CHURCH LADS BRIGADE, Castletown, who won the competition for all-round efficiency in 1900.

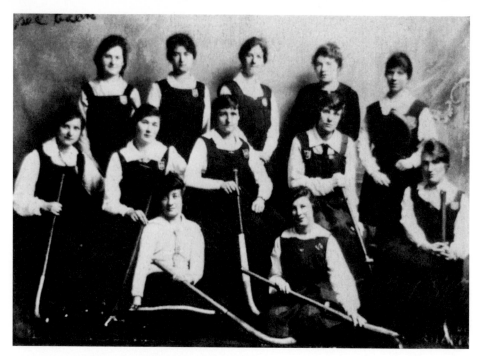

STAFFORD LADIES HOCKEY CLUB, 1919.

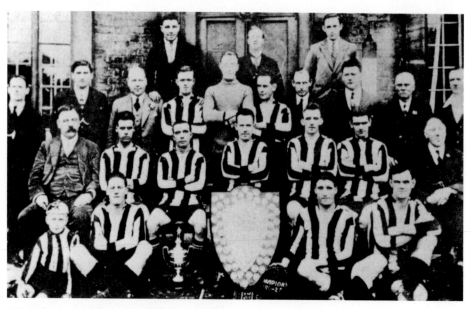

STAFFORD RANGERS, established in 1876, won the Birmingham League in 1926. The team moved to its present home on the Marston Road in 1896.

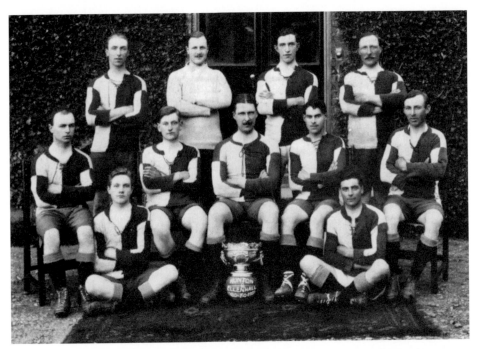

RANTON AND ELLENHALL FOOTBALLL CLUB, 1930/1, pictured outside Ranton Abbey.

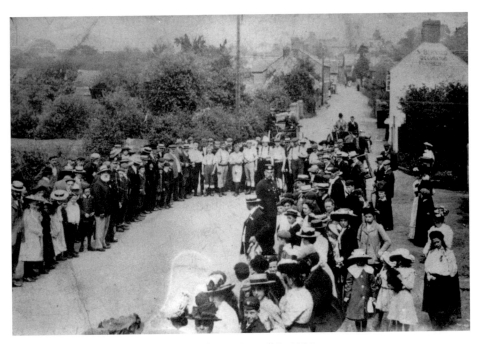

WALKING CONTEST on Hospital Sunday at Gnosall in 1905.

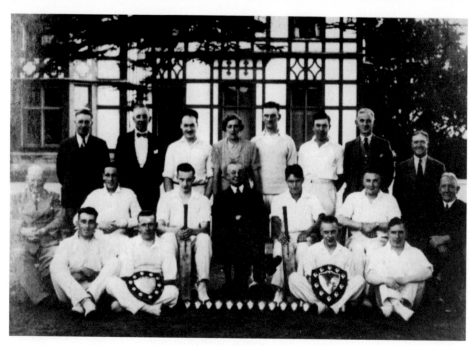

SEIGHFORD AND BRIDGEFORD CRICKET TEAM, winners of the Dobson and Wood Shield, 1939.

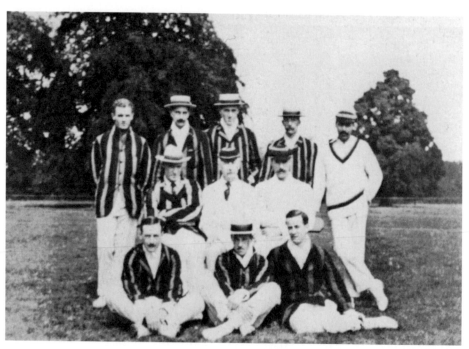

THE EARL OF LICHFIELD'S CRICKET XI IN 1912. The third Earl was keen on cricket and his team played many fixtures at Shugborough and other local venues.

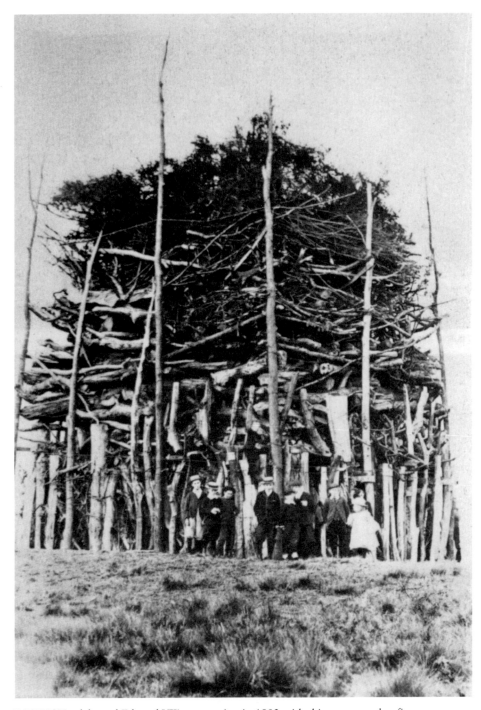

BASWICH celebrated Edward VII's coronation in 1902 with this enormous bonfire.

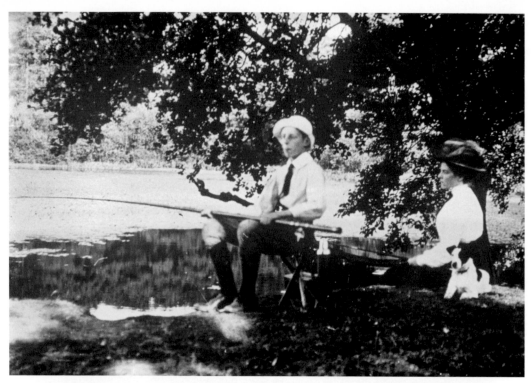

FISHING AT HOPTON POOLS, *c.* 1905.

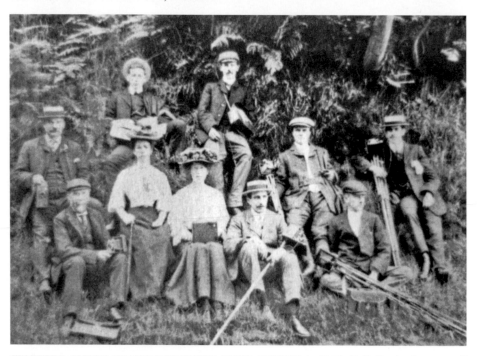

STAFFORD PHOTOGRAPHIC SOCIETY's FIRST OUTING in 1905. C. E. Fowke, later a well known Stafford photographer, is on the extreme right of the back row, wearing a cap.

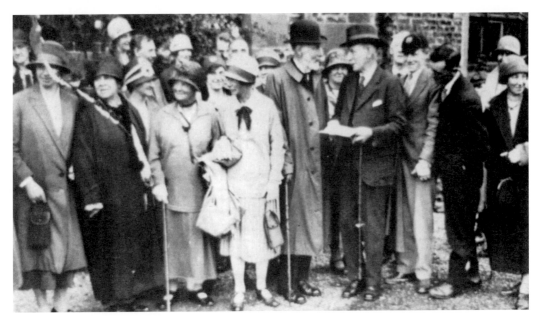

THE OLD STAFFORD SOCIETY with Lord Hatherton on one of their many outings; this one was to Pillaton Hall on 25th August 1925.

WORSTON MILL in the 1950s, the venue for another Old Stafford Society outing. The mill is now a restaurant.

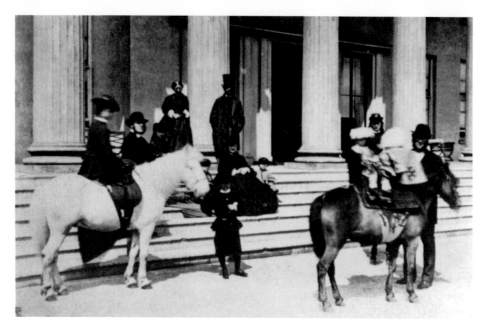

MEMBERS OF THE ANSON FAMILY setting off for a ride at Shugborough in 1863.

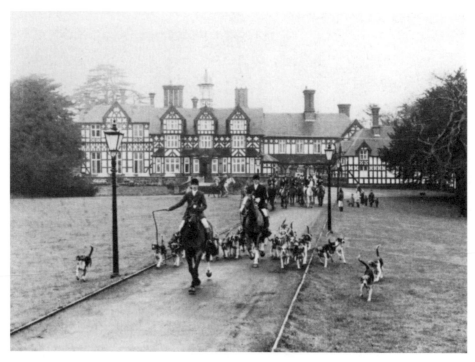

THE HUNT AT SEIGHFORD HALL in the 1960s.

CHAPTER NINE

ALL BEER AND SKITTLES

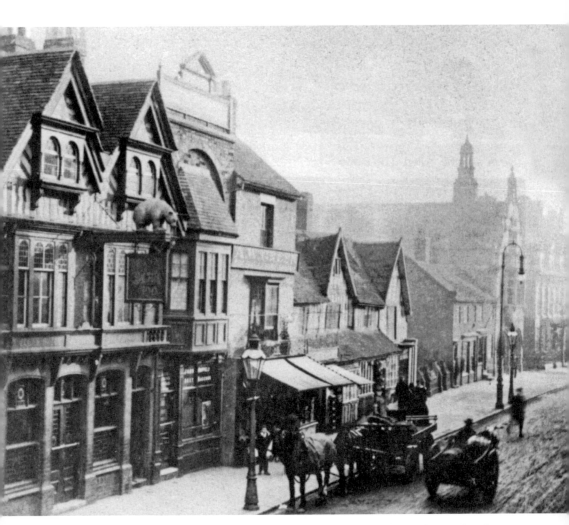

THE BEAR INN, Greengate Street, seen here in the 1890s, looks very similar on the outside today.

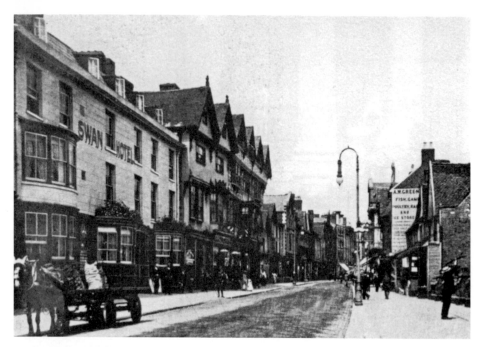

THE SWAN HOTEL, Greengate Street, *c.* 1904, formerly a coaching inn. Charles Dickens stayed here in what he called 'The Dodo'.

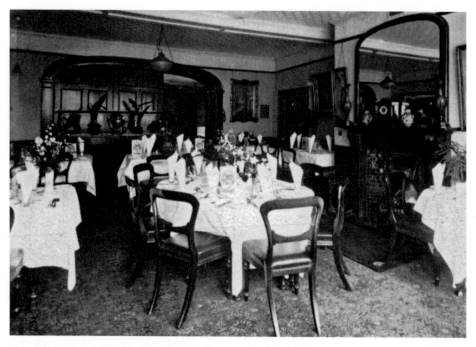

THE DINING ROOM AT THE SWAN, photographed in 1910.

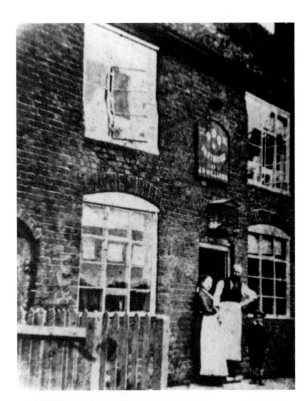

THE DOG AND PARTRIDGE in
South Walls, Stafford, *c.* 1890.

THE BACK OF THE NOAH'S
ARK INN in Crabberry Street,
c. 1877.

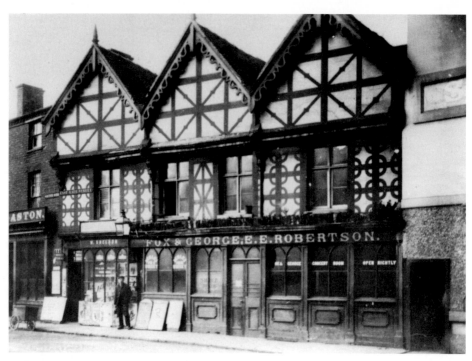

THE FOX AND GEORGE, Eastgate Street, Ernest Robinson was the licensee during the 1890s.

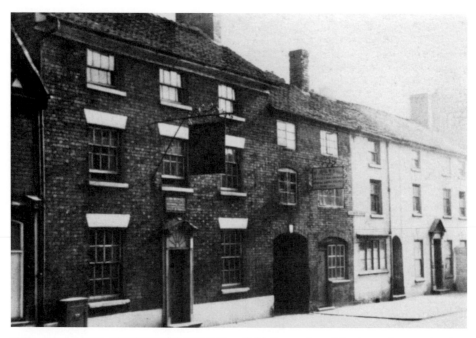

THE CASTLE INN, 10 EASTGATE STREET, *c.* 1900. It was demolished to make way for the telephone exchange.

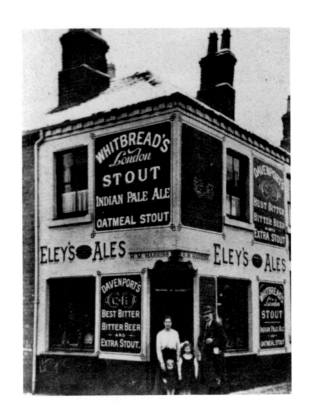

THE BEER SHOP at the corner of
Earl Street and Bath Street in the
1930s.

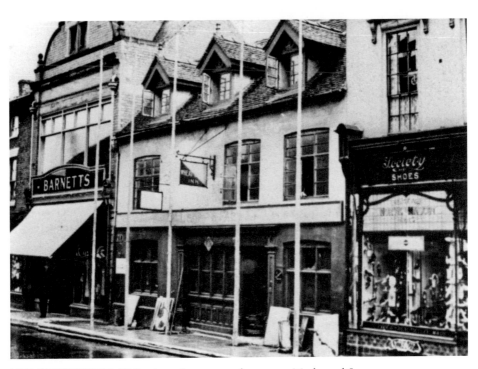

THE WHEATSHEAF, 29 Gaolgate Street, near the present Marks and Spencer.

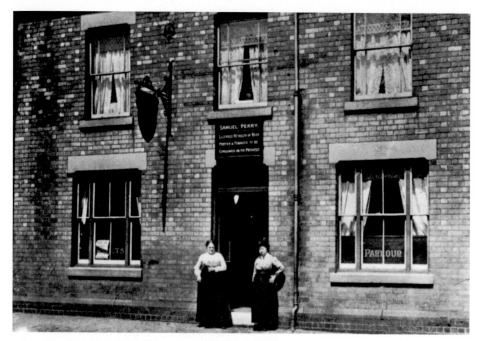

THE CROWN AND ANCHOR, Mill Street. Samuel Perry was the licensee between 1906 and 1915.

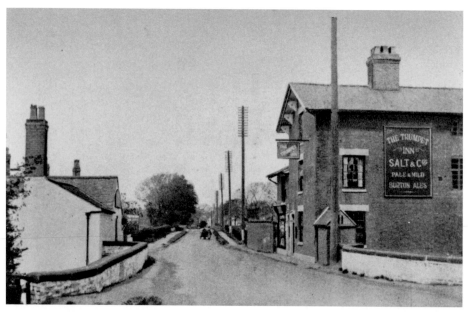

THE OLD TRUMPET INN at Radford Bank.

THE BARLEY MOW, Milford, 1910.

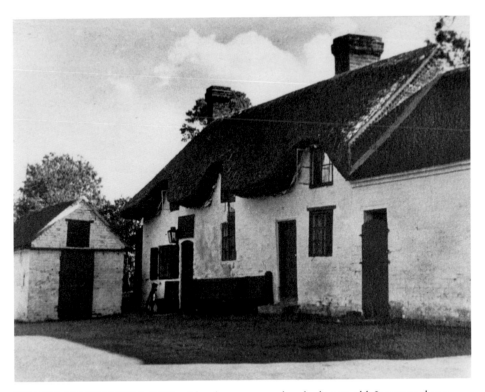

THE HOLLY BUSH, SALT, 1937, said to be over seven hundred years old. It was used as a baiting or feeding house for ponies and mules, carrying salt from Shirleywich to Stafford.

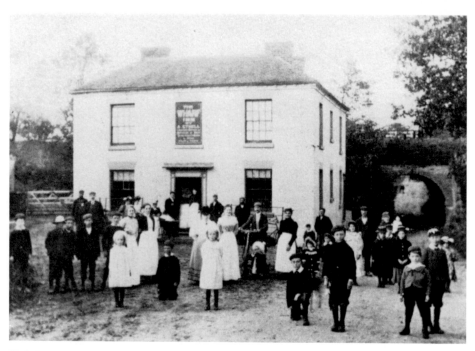

THE WHARF INN at Shebdon, *c.* 1904. Mrs. Ann Ethell, the licensee, was also a coal agent, no doubt because of the proximity to the canal.

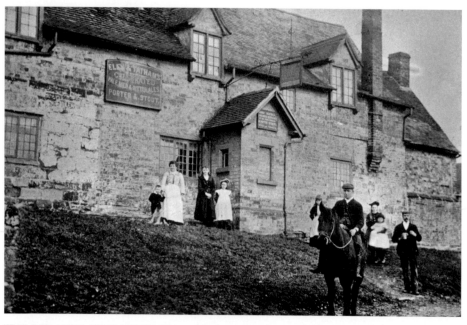

THE RED LION AT BRADLEY. This public house has been in business since 1851, and possibly before that.

CHAPTER TEN

HASSOCK AND CASSOCK

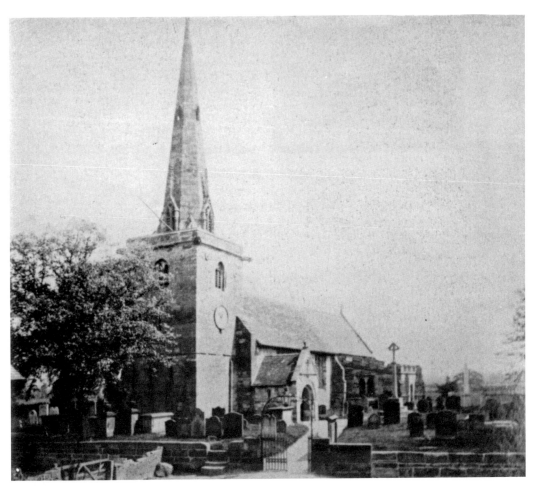

ST. EDITHA'S, Church Eaton, built of local sandstone, pictured c. 1910.

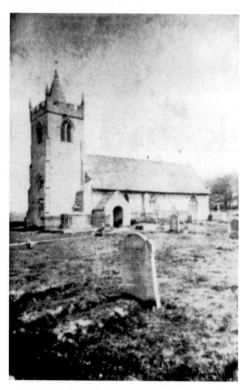

ST. JAMES' CHURCH, Acton Trussell, in 1866, before restoration by G. E. Street.

HOLY TRINITY, Baswich, *c.* 1905. This church is now almost surrounded by modern housing.

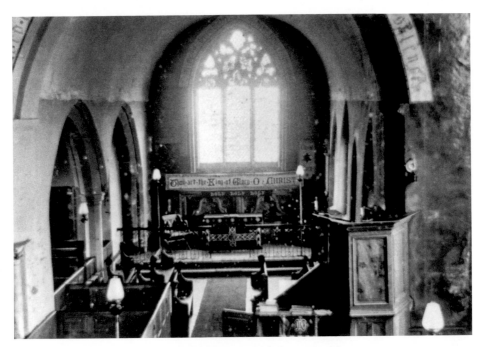

THE INTERIOR OF BRADLEY CHURCH in 1904 before restoration.

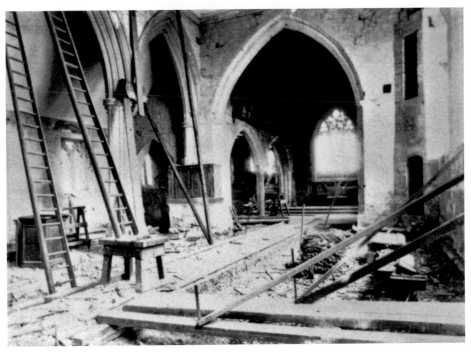

BRADLEY CHURCH during restoration work in 1907.

BROCTON MISSION ROOM, 17 June 1900. Built in 1891 at a cost of £200, it later became All Saints.

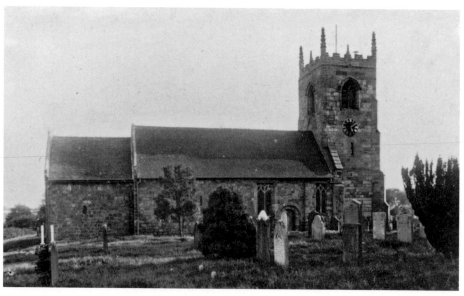

ALL SAINTS CHURCH, CHEBSEY, *c.* 1905.

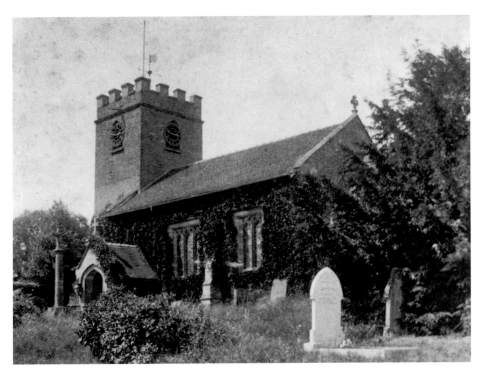

St. Mary's Ellenhall, *c.* 1920. Built in the Gothic style, it was restored in 1886.

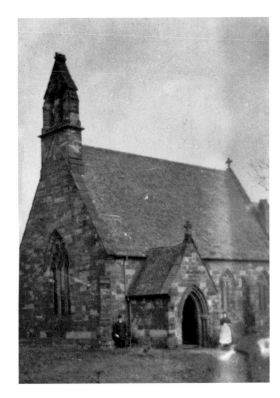

ST. MATTHEW'S DERRINGTON in 1902. This church was built completely at the expense of the rector of Haughton, Revd. C. S. Royds.

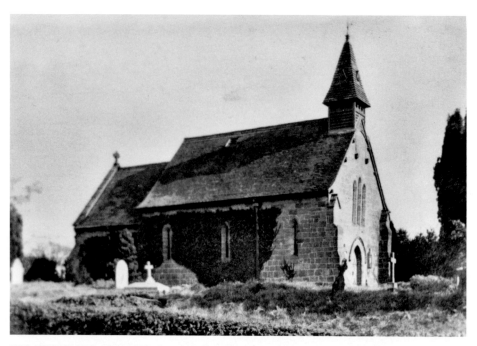

ST LAWRENCE'S CHURCH, Coppenhall, 1928. The wooden bell cote was placed on the gable when the church was restored in 1866.

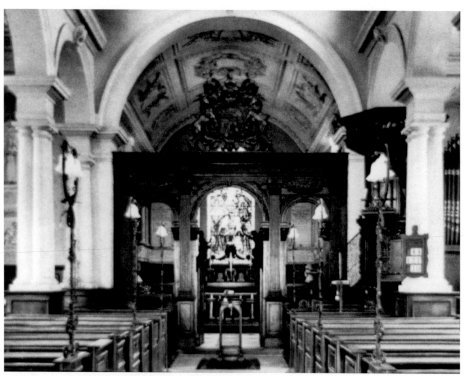

THE INTERIOR OF ST MARY'S, Ingestre, 1929. The church adjoins Ingestre Hall and is the only Wren church in Staffordshire.

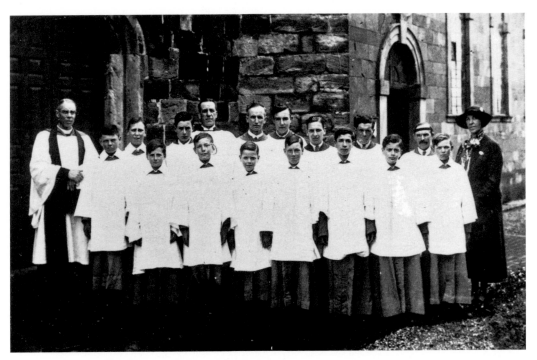

THE CHOIR OUTSIDE FORTON CHURCH from an undated photograph.

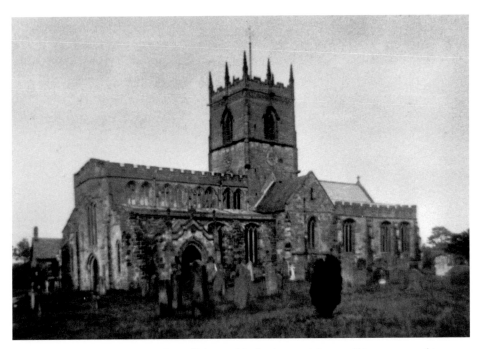

ST LAWRENCE'S CHURCH, Gnosall, is notable for its surviving twelfth-century architecture. This photograph was taken *c.* 1920.

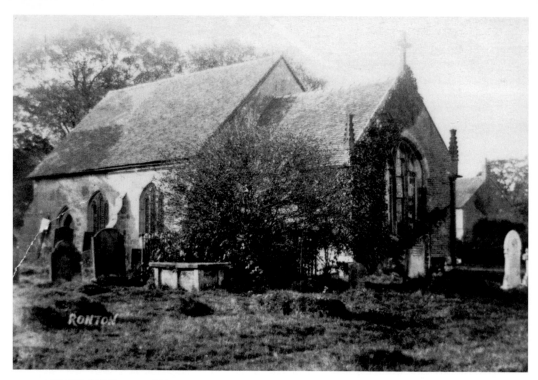

ALL SAINTS, Ranton, 1907.

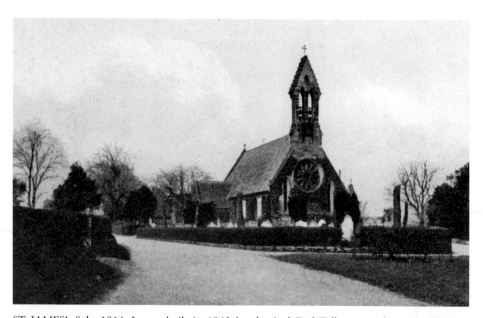

ST JAMES', Salt, 1914. It was built in 1842 by the 2nd Earl Talbot to a design by Thomas Trubshawe, the Haywood architect.

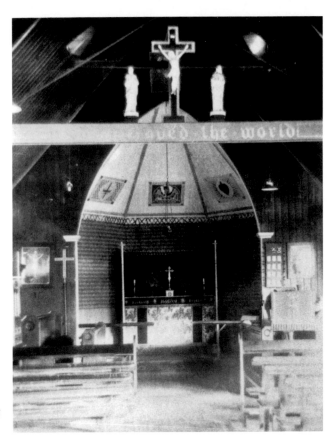

ST AIDAN'S MISSION
CHURCH, an iron church,
on the Marston Road,
Stafford, was opened in
1902 as a mission church of
Christchurch.

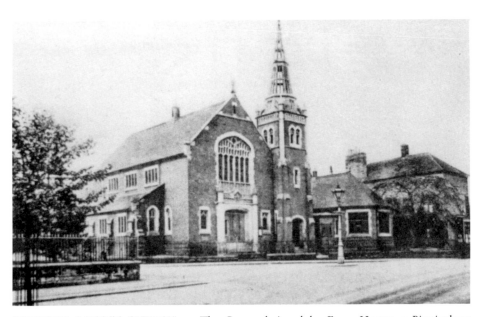

STAFFORD BAPTIST CHURCH on The Green, designed by Ewen Harper, a Birmingham
architect, was opened in 1896.

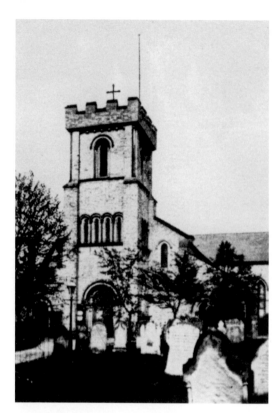

CHRISTCHURCH, Stafford, a
landmark at the north end of the town,
was consecrated in 1839, enlarged in
1863, closed in 1976 and demolished in
1983. Sheltered housing for the elderly
now stands on its site at the top of
Gaol Square.

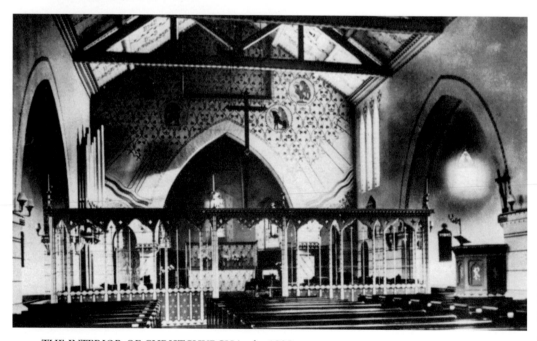

THE INTERIOR OF CHRISTCHURCH in the 1920s.

REVD THOMAS HARRISON,
first vicar of Christchurch, 'one
of the good old school', in 1855.

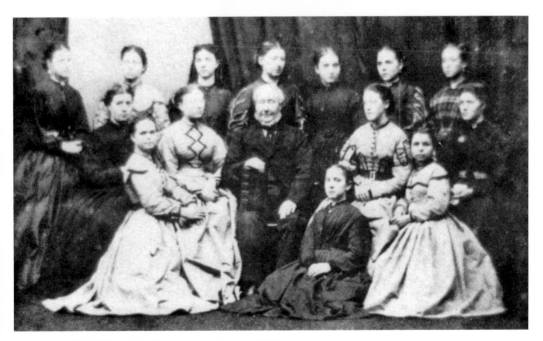

MR CROSBIE and his Sunday school class, 1870.

REVD GODDARD and Christchurch choir, *c.* 1905.

THE INTERIOR OF THE CHAPEL AT COTON HILL, the private asylum, which opened in 1854 and stood on the present site of Stafford District General Hospital. The chapel organ, a memorial to Dr Hewson, the medical superintendant, was installed in 1884.

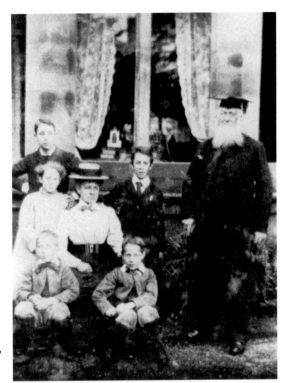

REVD. NORMAN, rector of St Mary's, Stafford, and his family outside the Rectory in Mount Street, 1898.

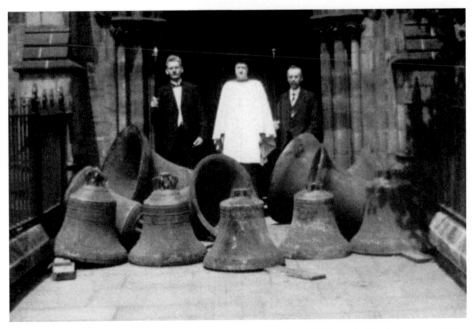

THE RECTOR, CHURCHWARDENS AND BELLS OF ST MARY'S, probably during the 1920s.

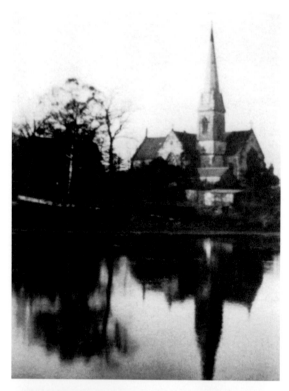

ST PAUL'S, Forebridge, reflected in floods. The tower and spire were added in 1887 to commemorate Queen Victoria's Jubilee.

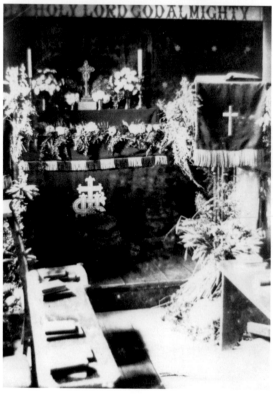

HARVEST FESTIVAL at the Diocesan Labour, Home chapel, Marston Road, in 1895.

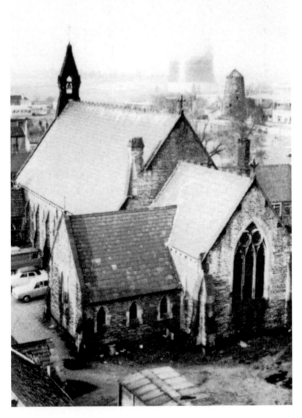

ST THOMAS'S, Castletown, built in 1866 for the railway workers living in that area of Stafford. The first incumbent was Revd Evan Kendall whose preaching attracted people, including many of the middle classes, from all over the town to a church not meant for them. It was said of these that 'fine silks and satins with extensive crinolines are a bar to the working classes in more ways than one'. The church was demolished in 1972.

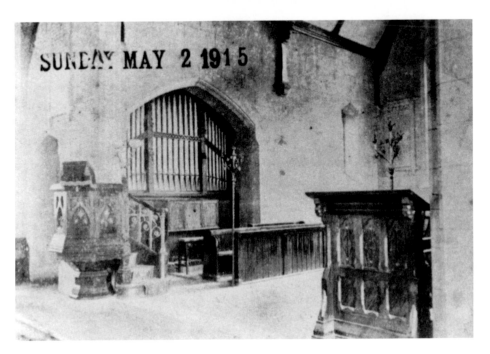

SUNDAY MAY 2 1915

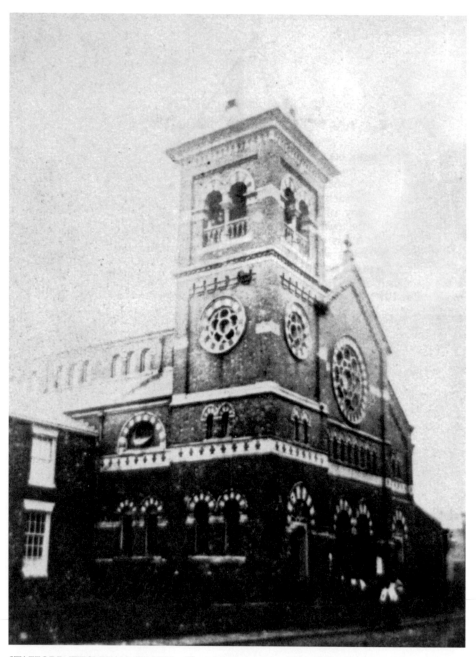

STAFFORD WESLEYAN CHAPEL, Chapel Street, in the 1880s. The chapel was demolished in 1987 to make way for the new Stafford market but its tower was retained.

CHAPTER ELEVEN

TREATS AND TRIBULATIONS

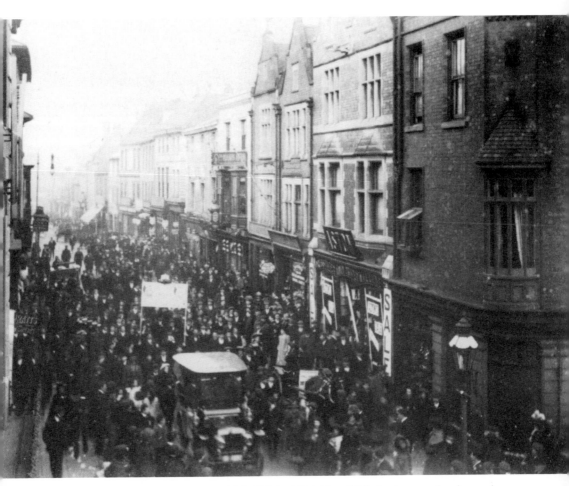

THE BIG AND LITTLE LOAF PROCESSION in 1906. The 1906 election was fought on the major issue of free trade versus protection. The Liberals favoured free trade and coined the slogan 'Big Loaf' (under the Liberals) or 'Little Loaf' (under the Tories and protectionism).

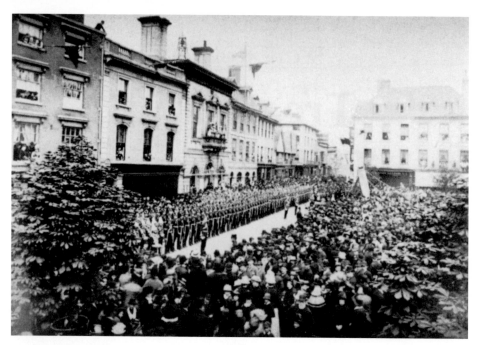

TO CELEBRATE QUEEN VICTORIAS DIAMOND JUBILEE in 1897, G Company of Stafford Volunteers fired a *feu de joie*.

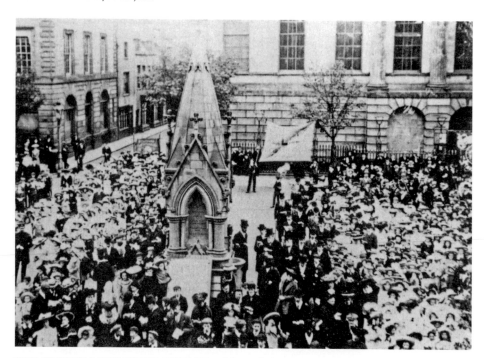

THE WESLEY METHODIST CHURCH celebrated the centenary of their Sunday school with this gathering in the Market Square in 1910.

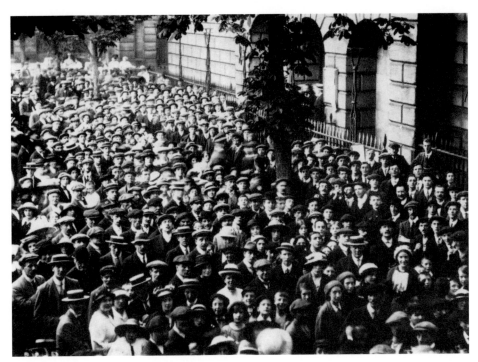

THIS CROWD OF PATRIOTIC YOUNG MEN were waiting to enlist for the army in 1914.

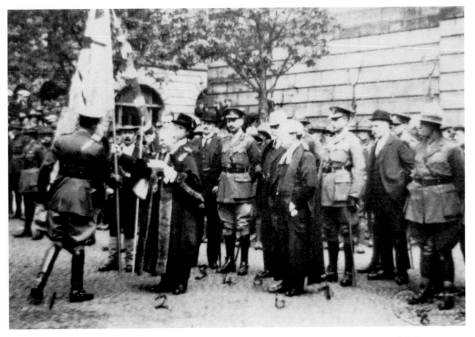

COMMONWEALTH TROOPS were stationed at Brocton Camp in the First World War.

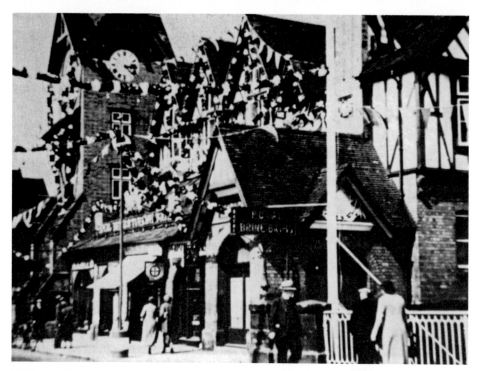

THE ROYAL BRINE BATHS decorated for the coronation of King George VI in 1937.

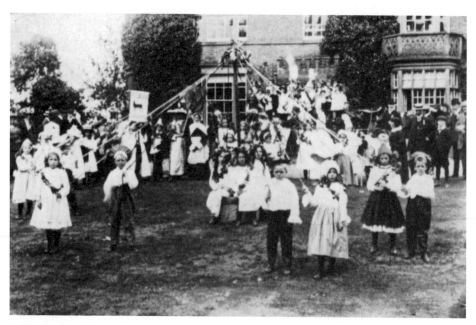

THE CORONATION OF KING GEORGE V was celebrated at Haughton with a Maypole on the Rectory lawn.

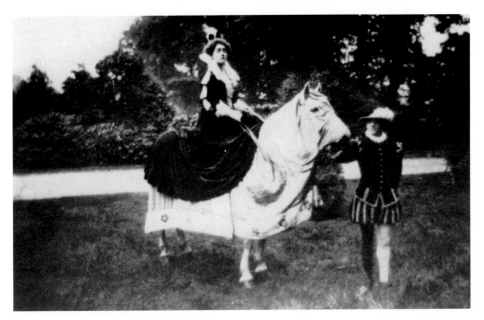

A MILLENARY PAGEANT was performed in the castle fields in 1913 to celebrate 1,000 years since Stafford's foundation in 913 by Ethelfleda. Many local people took part and visitors travelled to Stafford from miles away to see the event. In this photograph we see Queen Elizabeth I.

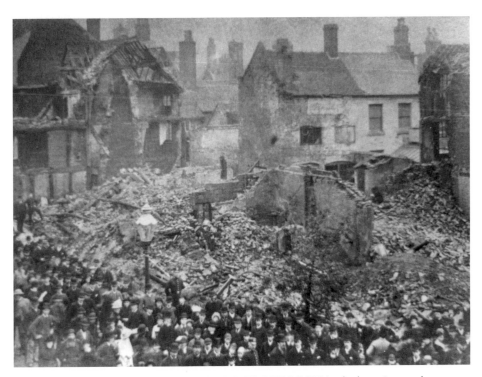

STAFFORD STILL HAD SOME FINE TIMBERED BUILDINGS in the late nineteenth century, but in November 1877 the corner of Gaolgate Street and Market Square burned to the ground.

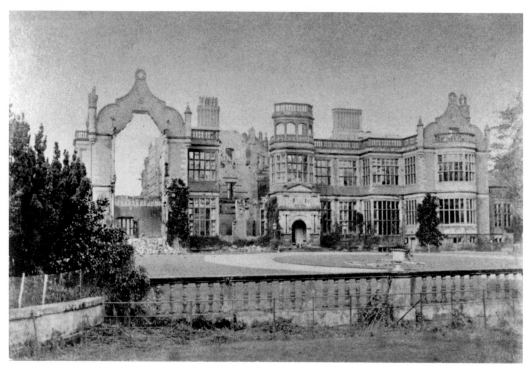

INGESTRE HALL, an Elizabethan mansion, was burned down in 1882, and was rebuilt in the same style in 1885 but with many modern improvements such as electric lights.

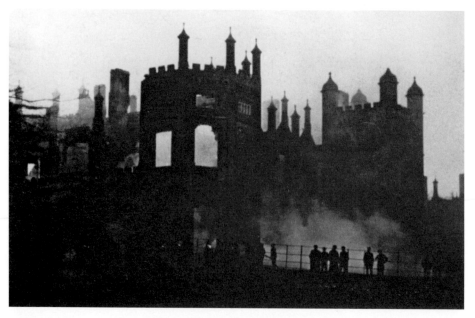

AQUALATE HALL, Forton, a fine Gothic mansion belonging to the Fletcher Boughey family, was sadly burned down in 1910.

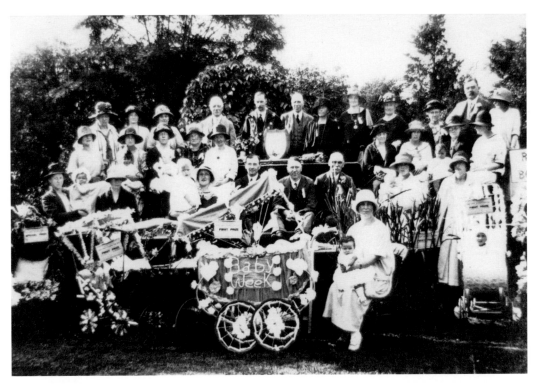

AN ANNUAL BABY DAY was organized by the Maternity and Child Welfare Committee of Stafford Corporation in the 1920s. Prizes were awarded for the bonniest baby and best decorated pram.

MAJOR ELD, Squire of Seighford, married in 1946. This group of tenants on the estate are seen celebrating the happy occasion.

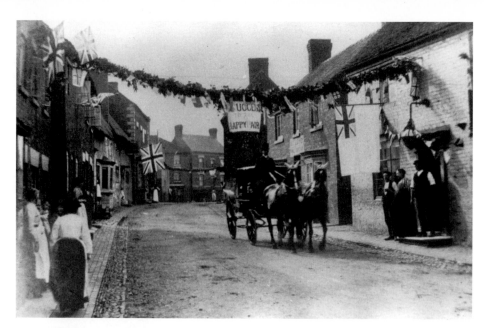

HIGH STREET, Gnosall, beautifully decorated in honour of a wedding. It may have been a local one but the Union Jacks suggest a royal wedding, perhaps that of the Duke and Duchess of York who were married in the early 1890s. They were to become King George V and Queen Mary.

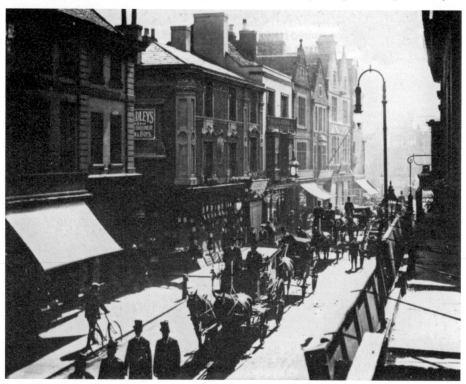

MATTHEW FOLLIATT BLAKISTON was Town Clerk of Stafford. When he died in 1906, the sombre funeral procession was taken through Stafford's main street.

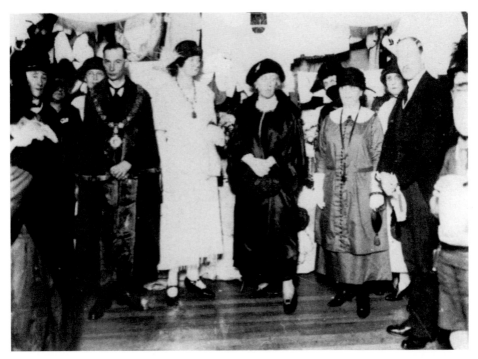

HRH PRINCESS HELENA VICTORIA visiting Stafford in 1925 to open a bazaar in aid of the new YMCA building in Camden Place.

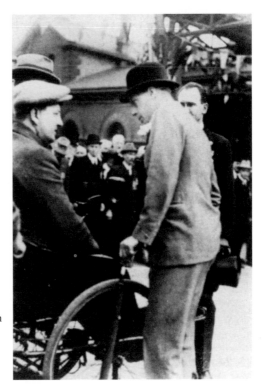

EDWARD, PRINCE OF WALES broke a journey in Stafford in the 1920s. He is seen here chatting to Sergeant Binns, a veteran of the First World War. The prince did not leave the station forecourt which can be seen in the background.

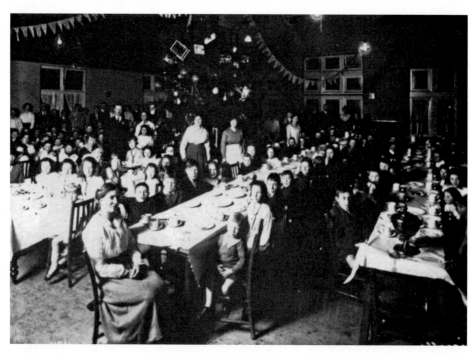

CHILDREN OF BAGNALL'S EMPLOYEES enjoying a Christmas party in the factory canteen in 1918. W. G. Bagnall founded the firm of locomotive builders in 1870.

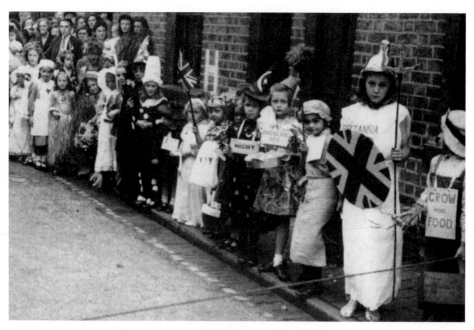

THIS FANCY DRESS PARTY was one of many street parties held to celebrate the end of the Second World War. Castletown's children wore costumes reflecting the times – 'Miss Utility', 'Mrs Mopp' of *ITMA* fame, 'Dig for Victory' and 'Britannia'.

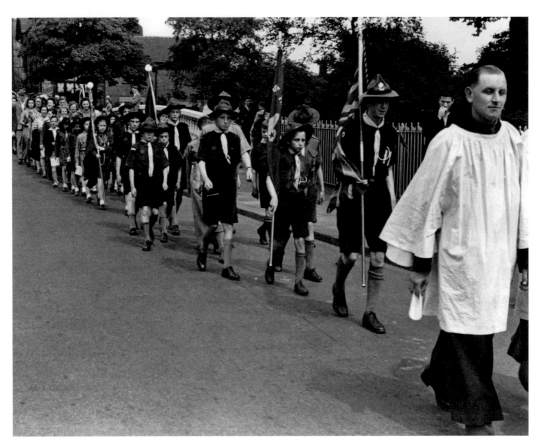

THIS PARADE was held in about 1946.

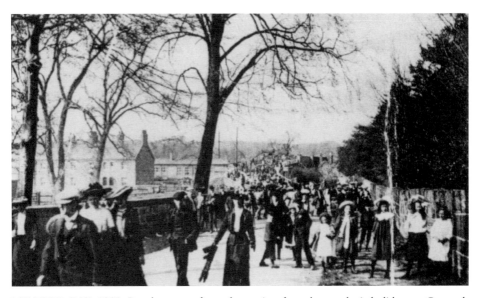

MILFORD DAY, 1900. People stream from the station for a happy day's holiday on Cannock Chase.

ACKNOWLEDGEMENTS

It is impossible to compile collections of photographs like this without the help and co-operation of many people. To all of those who have lent or allowed us to copy their own photographs or who have generously given information and time, we offer our grateful thanks. Some of the photographs lent to us were in themselves copies and, although we have made every endeavour to trace their origins, it has not always been possible to do so. We hope that we have not unintentionally wronged anyone in the production of this book, but, if we have done so, then please accept our apologies. We are sure that everyone who has been involved will be glad to know that all royalties are being donated to the Stafford District General Hospital towards the purchase of new surgical equipment; to the Stafford branch of the Royal Society for the Protection of Animals; and to the William Salt Library, Stafford, towards the preservation of its local collections.

In particular we must express our thanks to the Stafford Historical and Civic Society, who have allowed us to draw extensively on their photographic collection without reservation. Our thanks are also due to the Trustees and Librarian of the William Salt Library for permission to reproduce a number of items in their custody. In addition we would like to thank Mr Peter Atkins, Editor of the Stafford Newsletter, for allowing us to reproduce photographs from the former *Staffordshire Advertiser* and *Staffordshire County Pictorial*. We are also especially grateful to Mrs Hazel Ballance, for generously allowing us to draw on her collection of photographs and for all her help. In naming all the individuals and organizations who have helped us, we dread having forgotten anyone. Please forgive us if we have done so. The responsibility for all errors and omissions in the text rests entirely with us.

Mr D. Anslow • Mr C. Archer • Mrs E. Bagnall • Mrs C. Bayley • Mrs Bennion
Churchwardens and Parochial Church Council of Bradley • Mr P. Butters
Mrs Caldicott • Mrs Clarke • Mrs A. Clay • Mrs Deville • Mrs M. Dicks
Dorman Diesels Ltd • Mr P. Down • Mr H. Dyson • Mrs D. Egerton
Mr T. Field-Williams • Mr D. Y. Fowkes, County Archivist • GEC Alsthom
Mr C. Gough • Revd T. Hawkings • Prebendary R. T. Hibbert • Mr G. Holt
Mrs A James • Miss E. Jay • Mrs E. Kennett • Mr A Leese • The Earl of Lichfield
Lotus Ltd. • Mrs Mitchell • Mrs M. Mottershead • Mrs Nelson
Mr P. Newbold • Old Edwardians Association • Mr C. H. Pettifer • Mrs O. Pye
Dr AJ. Randall • Mr A Rogers • Mrs Rowlands • Mrs W. Rowney
Miss J. Saggers • Members of Seighford Thursday Lunch Club
The Earl of Shrewsbury • Stafford Photographic Society • Stafford Rangers
Staffordshire County Council: Departments of Education and of Libraries, Arts
and Archives • Staffordshire Schools History Service • Mr F. Taylor
Mrs L. Taylor • Mr Warburton • Mr C. Wheat • Mrs Young.

We hope that people will derive as much pleasure from seeing these old photographs as we have from compiling this all too brief selection.